Helen Chadwick
The Oval Court

Marina Warner

First published in 2022
By Afterall Books

Supported by the Paul Mellon Centre for
Studies in British Art

Afterall
Central Saint Martins
University of the Arts London
Granary Building
1 Granary Square
London N1C 4AA
www.afterall.org

Afterall is a Research Centre of
University of the Arts London

Editors
Elisa Adami
Amber Husain
Mark Lewis

Copy Editor
Alex Fletcher

Project Coordinator
Camille Crichlow

Associate Director
Chloe Ting

Director
Mark Lewis

Design
Andrew Brash

Typefaces for interior
A2/SW/HK + A2-Type

Printed and bound by
die Keure, Belgium

The One Work series is printed
on FSC-certified papers

ISBN 978-1-84638-251-2

Distributed by The MIT Press,
Cambridge, Massachusetts and London
www.mitpress.mit.edu

An Afterall Book
Distributed by The MIT Press

Each book in the *One Work* series presents a single work of art considered in detail by a single author. The focus of the series is on contemporary art and its aim is to provoke debate about significant moments in art's recent development.

Over the course of more than one hundred books, important works will be presented in a meticulous and generous manner by writers who believe passionately in the originality and significance of the works about which they have chosen to write. Each book contains a comprehensive and detailed formal description of the work, followed by a critical mapping of the aesthetic and cultural context in which it was made and that it has gone on to shape. The changing presentation and reception of the work throughout its existence is also discussed, and each writer stakes a claim on the influence 'their' work has on the making and understanding of other works of art.

The books insist that a single contemporary work of art (in all of its different manifestations), through a unique and radical aesthetic articulation or invention, can affect our understanding of art in general. More than that, these books suggest that a single work of art can literally transform, however modestly, the way we look at and understand the world. In this sense the *One Work* series, while by no means exhaustive, will eventually become a veritable library of works of art that have made a difference.

Helen Chadwick
The Oval Court

Marina Warner

I would like to thank Amber Husain for inviting me to write this volume in the Afterall series; I leapt at the chance and appreciate her enthusiasm and perspicacity in the initial stages; Elisa Adami then took up the editing and I am most grateful to her for her help, and to Alex Fletcher for his care in copy-editing. I am indebted to Helen Chadwick herself for conversations and for the many catalogues and leaflets she oversaw after *Of Mutability*; also to several curators and posthumous exhibition catalogues, especially Mark Sladen's *Helen Chadwick: A Retrospective*, London: Barbican Art Gallery, Hatje Cantz Publishers, Ostfildern-Ruit, 2004; the research of Stephen Walker and Imogen Racz (see the Notes at the end of this volume) has been invaluable; my understanding of Helen Chadwick's oeuvre has also benefitted immeasurably from the contributions of Mark Haworth-Booth, in particular through the conversations he recorded with the artist for the British Library Sound Archive. Errin Hussey, archivist at the Henry Moore Institute, Leeds, guided me expertly through Chadwick's papers. I am also very grateful to Martin Barnes and Hana Kaluznick at the V&A for making it possible, in the thick of the pandemic, to see Chadwick's originals. Hannah Machover has helped me impeccably with the referencing and the formatting. Roger Malbert, Louisa Buck and Pete Smith kindly read drafts of the essay and the latter gave permission to use his 1979 polaroid of Helen; David Notarius over the years has shared many memories of Helen with me; Alison Turnbull's reminiscences illuminated for me aspects of her personality and her art. Richard Saltoun has been more than generous in granting permission to reproduce works by Chadwick and artists whom she admired. My profound thanks to them all.

Marina Warner writes fiction and cultural history. Her award-winning books explore myths and fairy tales; they include *From the Beast to the Blonde* (1994) and *Stranger Magic: Charmed States & the Arabian Nights* (2011). She has published five novels and three collections of short stories, including *Fly Away Home* (2014). Her essays on literature and art have been collected in *Signs & Wonders* (1994) and *Forms of Enchantment: Writings on Art and Artists* (2018). Her most recent book, *Inventory of a Life Mislaid* (2021) is an 'unreliable memoir' about her

childhood in Egypt where her father opened a bookshop in 1947. She contributes regularly to the *New York Review of Books* and the *London Review of Books* and to artist's catalogues, for example for Paula Rego's retrospective at Tate Britain (2021). She is Professor of English and Creative Writing at Birkbeck College, a Distinguished Fellow of All Souls College, Oxford, and a Fellow of the British Academy. In 2015, she was awarded the Holberg Prize in the Arts and Humanities. Since 2016, she has been working with the project www.storiesintransit.org in Palermo, Sicily, and is currently writing a book about the concept of Sanctuary. She lives in London.

For Rachel with love

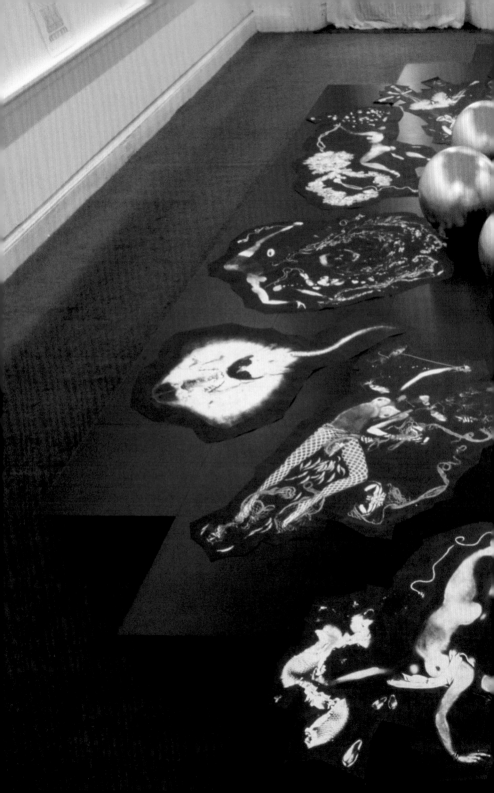

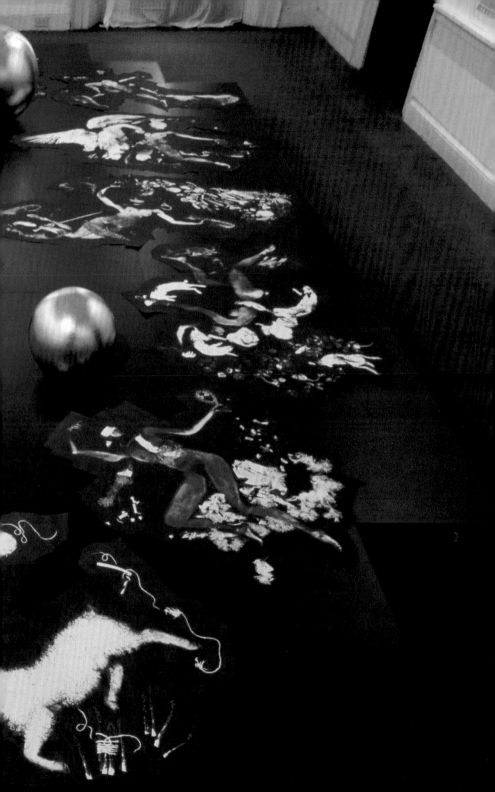

Contents

At the ICA, London, 1986

At first sight, *The Oval Court* communicated blissful hedonism: the figures depicted, lunar pale against the ultramarine blue oval plinth, were not entirely naked, but bedecked in pearls, stockings, bracelets, rings and necklaces, and trailing white lace and ribbons, fripperies and flounces, braid, fringes and tassels (fig.1-6). As they danced, arched and floated in the blue of the 'Pool of Tears', and frolicked with all kinds of species of creature, the overall impression was of a female bacchanal taking place, in a fantastic nymphaeum such as the Emperor Tiberius built on Capri. The animals that the artist in her different incarnations was consorting with were mostly edible species, including crustaceans, squid, a monkfish and a skate. At a closer look, starfish, bees, mice, snails and fish bait were also taking part, offal (a kidney or two) was scattered here and there, along with a few bones. The guts, also discarded in dressing an animal for the table, appeared alongside many kinds of flowers, fruit and vegetables, mostly from the exotic end of the range - artichokes, a pineapple, asparagus - and homely greens, too - a dandelion, a cabbage sliced in two. The spirit of an unfettered quest for pleasure was avid for anything and everything, it seemed.

Against the deep blue of the photocopier's digital ink, the figures' pallor - an effect close to a solarised halo - took on a blueish blush, especially in the shadows sculpting their limbs. They seemed spectral, imaginary beings dancing in a round in the elements of air and water - 'constellations on blue - as clouds - vapour ...', wrote the artist in her preparatory notes.[1] Bubbles speckled the blue here and there. There was no orientation or clear progression from one to another to be grasped - the whole was dream-like. However, if you considered the pool as a compass, one naked figure at due south, in short cotton socks, was vaulting upside down, a crucifix dangling from her neck, to meet the muzzle of a lamb in a kiss (fig.1). Then, moving round westwards, as it were, floated another apparition, wearing fishnet tights and deploying seaweeds, squid and fish, as if flowing from her body. With an oyster suspended on a string, she was swimming upwards towards the centre of the throng - the artist notes here '(water) birth/fertilisation (ocean)'.[2] Between this figure and an aquatic sister acrobat, a single giant skate hung in the blue element, all alone and spectral, weirdly smiling like the Man in the Moon (fig.4). Each dancer alternated their relation to the centre, this one facing outwards, the next inwards. On the right side of the duet with the lamb,

another variation on the same female figure was holding a mirror (fig.6); next to her another was brandishing rabbits, and next to her, at due east, a stream of nature's bounty drifted from the mouth of the naked girl, rising out of a woven basket; she personified a cornucopia, filled to bursting with delights (fig.5). Next to her, a huge goose gripped its partner in their dance, recalling the amorous twinings of Leda and the swan, for the bird appeared larger than life-size, on the same scale as his consort and treading webbed feet on her belly; her face was hidden under a whorl of bandages (fig.3). Next to them, the most gymnastically contorted figure of all had knotted her limbs, the better to lick herself. Across from her, ribbons and foliage and seaweed drifted over the head of another nymph, who was wearing striped stockings. The twelfth emblem, at due north, opposite the lover with the lamb, was a powerful, erect, double-headed figure, flourishing a sheaf of ripe cereals and fruits in her right hand and a bundle of sere thistles in the other (fig.2). A dozen nudes, they alternated in their dance, now their heads towards the centre, now turned to the viewer standing around in the outer world, giving a rhythm to the whole assembly. Months of the year, hours in the day, signs of the Zodiac? It was not determined, the throng was shifting and nameless, but they hinted at the wheeling of the heavens, with catasterised beings such as Ariadne or Berenice.

The overall impression was of nature teeming and breathing, bubbling and swelling, exuding and leaking, conveying 'jouissance', a term the artist hits upon in her notebooks, where you can see her intent on her ideas, circling them in restless excitement: 'Potency of sexual flesh', she noted, 'celebrates its solitary sublime state of non-possessibility to [an]other.'[3] Behaving as mischievously as Cupid himself, the artist added a feather angled towards the derrière of one of her riggish alters.

The artist's notebook for that year reveals her in a tumult of ideas and visions as she conceived the piece in all its grandeur: 'I a subject/object: artist/artwork/model...

12 notes in dance dreamscape [...] as frieze of figures

12 volutes of Love'[4]

She realised these images by photocopying her own body, the animals and all the other elements, in a series of self-fashionings, performances or attitudes. When I first entered the grand upstairs rooms at the Institute of Contemporary Arts (ICA) where her show was first installed, the overall

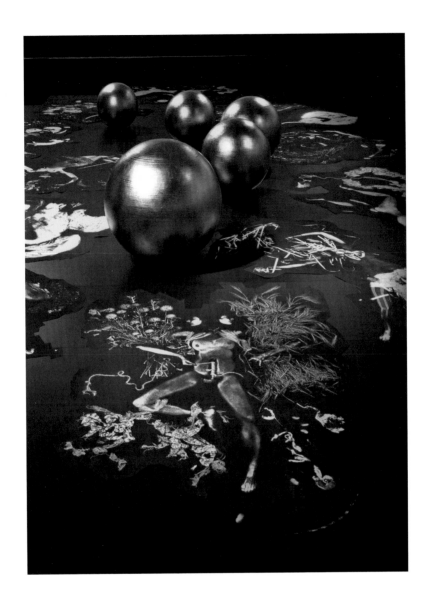

2. Helen Chadwick, *The Oval Court*, 1986, collage of blue photocopies and five golden spheres, detail of 'August. Harvest. Fire.' © Leeds Museums & Galleries (Henry Moore Institute archive) and The Estate of Helen Chadwick

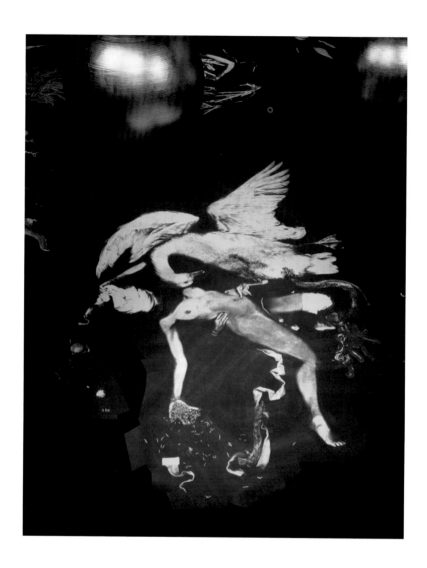

3. Helen Chadwick, *The Oval Court*,
1986, collage of blue photocopies,
detail of Leda and the Swan © Leeds
Museums & Galleries (Henry Moore
Institute archive) and The Estate
of Helen Chadwick

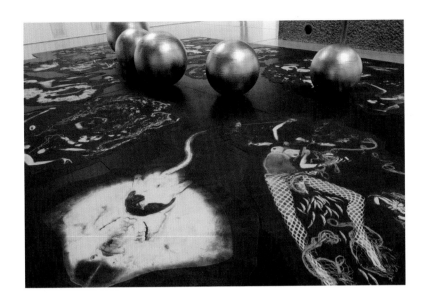

4. Helen Chadwick, *The Oval Court*,
1986, collage of blue photocopies,
detail of the skate. Installation shot
at the Barbican, London, 2004
© The Estate of Helen Chadwick /
Victoria and Albert Museum, London

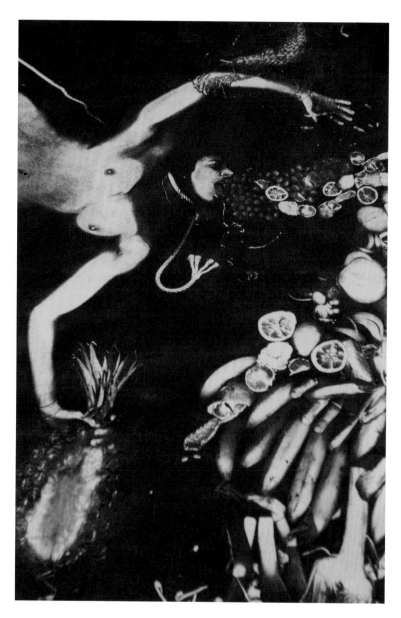

5. Helen Chadwick, *The Oval Court*,
1986, collage of blue photocopies, detail
of Cornucopia. Installation shot at the
Barbican, London, 2004 © The Estate of
Helen Chadwick / Victoria and Albert
Museum, London

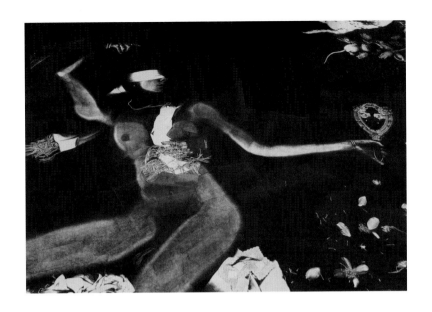

6. Helen Chadwick, *The Oval Court*,
1986, collage of blue photocopies, detail
of Venus. Installation shot at the
Barbican, London, 2004 © The Estate of
Helen Chadwick / Victoria and Albert
Museum, London

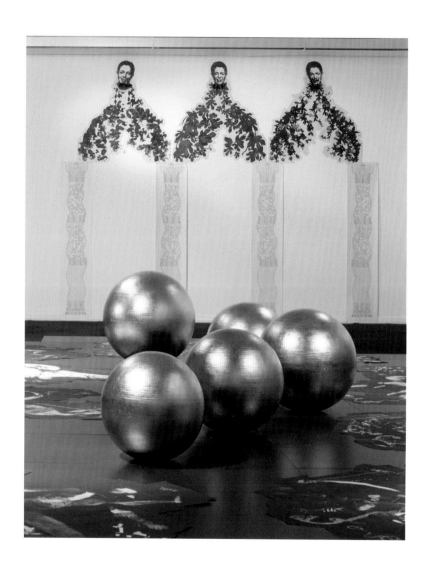

7. Helen Chadwick, *The Oval Court*,
1986, computer-drawn columns and
five gilded spheres, part of the instal-
lation *Of Mutability*. Installation View,
Institute of Contemporary Arts, London
© Leeds Museums & Galleries (Henry
Moore Institute archive) and The Estate
of Helen Chadwick

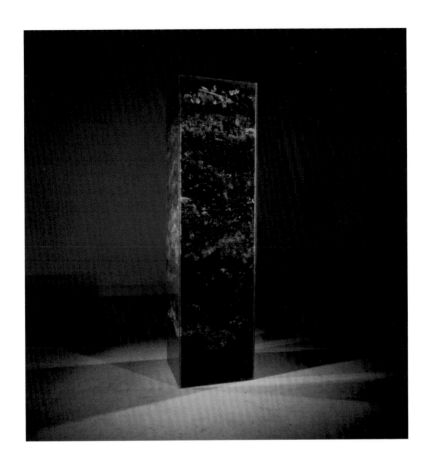

8. Helen Chadwick, *Carcass*, 1986, part
of the installation *Of Mutability*. Instal-
lation View, Institute of Contemporary
Arts, London © Leeds Museums & Galler-
ies (Henry Moore Institute archive) and
The Estate of Helen Chadwick

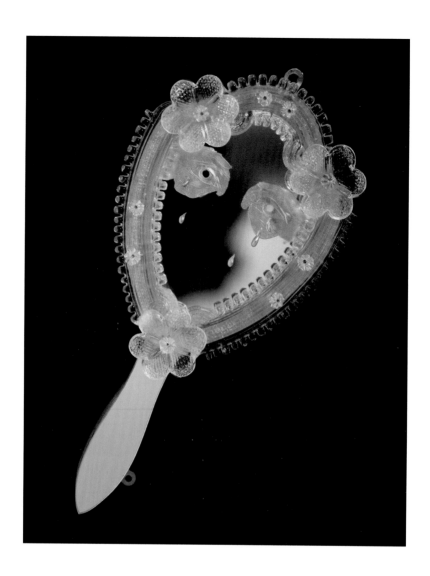

9. Helen Chadwick, *Vanitas*, 1985,
photocopies on board, with engraved
Venetian glass. © The Estate of Helen
Chadwick / Victoria and Albert Museum,
London

impression was of joyous buoyancy: the artist's multiplied bodies, back bends and twists intensified their sympathy with baroque angels, as if we were looking into a mirror in a Roman palazzo to see the painted ceiling above. Sharing the same dais stood five golden spheres, in graduated sizes determined by the ratio of the artist's fingers and thumb, arranged in an arc. They exuded an aura of ideal Platonic harmony and preciousness, and in their golden and geometric perfection counterbalanced the orgy in the pool – a 'Pool of Love', she called it in her preparatory notes.[5] Her fantasy paradise was not fallen, 'her self as naked [was] immune to shame. Not licentious ... but declare power of love – redemptive and liberating freed from Adamic contagion ... Apotheosis of sexual self virile & celebratory.'[6]

However, as I lingered to absorb the detailed pageant of pleasure, and began to take in the whole scenario, the effect of rapture became complicated. The pool was being fed, it was implied, by the tears shed by the weeping faces on the walls around the pool, grimacing in different expressions of sorrow. For these portraits, the artist had photographed herself using another mechanical medium of reproduction, the automated passport photo booth. These portrayals of grief stood at the apex of twelve arches, formed from lavish swags of fruit and flora, each one different, a tangled profusion of brambles, vine, fig leaves, olive and honeysuckle; this evidence of nature's bounty stood on twin barley-sugar Solomonic columns, also wreathed in vines and scattered with bees (fig.7). To create this architectural setting, the artist had adopted another new technology and commissioned computer drawings from photographs she had taken in Rome of Gianlorenzo Bernini's *Baldacchino* – the ornate canopy over the high altar in St Peter's Basilica, which is likewise topped by crying female faces.[7] Sorrows are hinted at, subliminally, by those brambles, too.

For a work the year before, *Four Walls* (1985), Chadwick noted:

> *It is said a wall was the primary architectural event – the thicket of brambles around Eden – and it is to be the last – the jasper edifice skirting the celestial city of Gold ...*
> *Graceless they mock our fall from Nature.*[8]

Chadwick's notes here anticipate the palisade of mourners around *The Oval Court*. They also show how her underlying mood was elegiac, even morbid.

At the centre of the grieving arcade encircling the Pool hung an exqui-site glass hand mirror, with rosettes on the frame in the style of Murano glass from Venice; a pair of eyes, also crystalline, also crying, were looking out from it (fig.9). The tears Chadwick showed herself squeezing out were the waters feeding the Pool where, in another realm of experience, she was cavorting in insouciance and delight. *Lacrimae rerum*, the tears of things, were the inevitable accompaniment of the 'wanton play' her alter ego in the pool was enjoying in her twelve different aspects.[9] The bacchanal was 'a dance of death in an amoral post-Christian space.'[10]

Chadwick was close-reading books about imagined enclaves of delight: Joseph Rykwert's seminal study of original architecture, *On Adam's House in Paradise: The Idea of the Primitive Hut in Architectural History* (1972); Naomi Miller's *Heavenly Caves: Reflections on the Garden Grotto* (1982); and William A. McClung's *The Architecture of Paradise* (1983), in which gar-dens and especially grottoes figure as liminal sites, artificial constructions which imitate nature, striving to look artless in order to provide a private place for fantasy.[11] The idea of the central pool in which her figures were floating was inspired by watery grottoes, such as the nymphaeums at Capri and at the Villa Giulia in Rome – sites of pleasure between the elements of earth, sea and sky; Chadwick then fused this imagery with Christian yearnings to regain the earthly Paradise, found at the summit of the Mountain of Purgatory in Dante's *Divine Comedy*, for instance, or the Garden of Earthly Delights as depicted in Hieronymus Bosch's triptych. The artist was recreating a prelapsarian paradise, a pagan playground, but it was also a symbolic place for reverie, an imaginary world where the artist could pursue what was to her a 'devotional' activity,[12] an 'internal meandering'.[13]

On the other side of the ICA's exhibition rooms, in the smaller space giving onto the Mall, stood a square glass column packed with detritus from the materials Chadwick had gathered and photocopied to incorporate into the work (fig.8). This vertical compost heap, titled *Carcass*, stood alone in the darkened room, seven feet high, solemn as a cenotaph. Over the previous nine months, the artist had bagged up everything she had used to make the tableaux in the pool, and then asked her neighbours in Beck Road, Hackney, to give her their organic rubbish, too. But she drew back from adding meat or any animal waste matter – she was aware from the start of the putrid pos-sibilities. With the choice of title, Chadwick, who always chose words care-

fully, wanted to indicate the terminal significance of this memorial and, with a shaft of irony, signal the inevitable end of beauty and pleasure. The 'twin aspects' of the installation, she noted, were 'Not in opposition or conflict but integrative, complementary'.[14]

The summer of 1986 brought a major heatwave, and the matter inside the glass column began to bubble and fizz and expand as it decomposed. After the glass case began leaking and the smell grew stronger and stronger, the ICA staff panicked, and tried to lay the column on its side, with catastrophic consequences: liquid manure exploded onto the carpet filling the rooms with its appalling stench. There was consternation: would the miasma waft to Buckingham Palace, just up the Mall, and envelop the royal family in its reek?[15]

'You could smell it,' Chadwick remembered, 'as you approached the Mall, but not offensively. It was a farmyard smell, really good compost. A friend of mine arrived from Greece and thought, The Café's gone organic!'[16] Besides, putrefaction was the point she was making; the whole exhibition, under the title *Of Mutability,* was structured as a diptych, with *The Oval Court* counterpoised by *Carcass*, deliberately evoking the potency of those natural forces that drive the pleasure principle, as well as the decay that follows, the further transformation into fertilising riches. 'Ironically,' Chadwick reflected, 'it became more of a metaphor of life than *The Oval Court*, stretched out like a blue corpse in the next room.'[17]

The artist had not been consulted about the attempt to move *Carcass*, and she was incandescent with rage. She felt her conception of the whole had been 'truncated' and in her protest to Bill McAllister, the director of the ICA, she considered withdrawing it from further exhibition.[18] She was persuaded otherwise, and *The Oval Court,* sometimes renamed, in a gesture to Europe, *La Cour Ovale*, travelled – to the Ikon in Birmingham, where Chadwick herself thought it looked better than at the ICA, and later to other venues including, ultimately, Freiburg in Germany.[19] In 1989, the V&A included the central pool of tears in their exhibition 'Photography Now', but in a rather cramped space.

Because *Carcass* was destroyed less than a month into the show's run, the full conception of the sculptural installation has never been seen again. Like a dance piece or a play, *Of Mutability* can never be fully regained, and *The Oval Court*, originally the title of the first room only, has gradually come to replace the work's full title. Yet it would not be impossible to give a sense of

Chadwick's original vision. In the same way that a choreographer revives a classic work, it could be reassembled, maybe with the use of photographs to represent the original diptych structure.

The destruction of *Carcass* did not daunt the artist in continuing her quest to breach the divide between art and nature, and to persevere in her search for unexpected, often base, despised, even revolting matter, to transform their associations and recalibrate, through a reinvigorated aesthetics, emotional and sensory consciousness.

Of Mutability, the overall title of Chadwick's meditation on metamorphosis and transience quotes Edmund Spenser's sixteenth-century *Faerie Queene*, and the address he makes at the beginning of the two cantos entitled 'Of Mutabilitie':

> *Proud* Change *(not pleasd, in mortall things,*
> *beneath the Moone, to raigne)*
> *Pretends, as well of Gods, as Men,*
> *to be the Soueraine.*

In the catalogue of the ICA show, she included as an epigraph these verses from Spenser's poem:

> *And first, the Earth (great mother of vs all)*
> *That only seems vnmov'd and permanent,*
> *And vnto* Mutability *not thrall;*
> *Yet is she chang'd in part, and eeke in generall.*

> *For, all that from her springs, and is ybredde,*
> *How-euer fayre it flourish for a time,*
> Yet see we soone decay; and, being dead
> To turne again vnto their earthly slime:
> Yet, out of their decay and mortall crime,
> We daily see new creatures to arize;
> *And of their Winter spring another Prime,*
> *Vnlike in forme, and chang'd by strange disguise:*
> *So turne they still about, and change in restlesse wise.*
> (VII, vii. 17-18. Emphasis added)

The necessary transformation of all that is 'fair' into decay and earthly slime could not be closer to what happened when *Carcass* began to ooze over the carpet of the ICA.

Commenting on the events eight years later, during the in-depth conversations she held with Mark Haworth-Booth, then Senior Curator of Photographs at the Victoria and Albert Museum (V&A) in London, Chadwick points out that the ICA's insurance paid for a much more handsome new floor than the manky old carpet that was there, and the stink drove out the tenants of the upstairs floor, so the ICA was able to expand at a peppercorn rent, thus fulfilling the laws of mutability.[20]

At the V&A, London, thirty-five years later

Enjoyment is a kind of work.
– Helen Chadwick[21]

The surviving elements of *The Oval Court* might well have been thrown away, after its tour. The artist could not have afforded to store them herself, and if she had, they might have been burned in the fire that consumed the MoMart stores in 2004, when several major later works of hers were lost.[22] Fortunately, Haworth-Booth at the V&A was a visionary curator; he decided that the Museum's pioneering role in recognising photography as an art form should continue in relation to contemporary artists. He had already bought Helen Chadwick's profane variation on the Madonna and Child (*One Flesh*, 1985, fig.13) and a *mise en scène* posed by herself (*Vanitas*, 1985). On the strength of the ICA show, he nominated her for the Turner Prize – she and Thérèse Oulton were the first women to appear on the shortlist. Declan McGonagle, who had been briefly at the ICA in 1983, was also nominated; with the curators Iwona Blazwick and James Lingwood, he had been involved in the original commission of *Of Mutability*. The other artists that year were Patrick Caulfield, Richard Long and Richard Deacon. Chadwick exhibited *Tre Capricci*, for which she projected her face, again screwed up in anguish, on to fantastic rococo cartouches stretched with flesh coloured suede.[23] She also called them 'Trophies to Misery'.[24]

Helen found the public exposure of the evening a terrible ordeal even before the winner, Richard Deacon, was announced. She still had no gallery to represent her, as would continue to be the case throughout her career. Her survival was precarious and it was therefore a huge relief when Haworth-Booth persuaded both the head of the V&A's Department for Prints, Drawings, Paintings and Photographs, and the museum's Director Elizabeth Esteve-Coll to purchase *The Oval Court*.[25]

Chadwick was not a photographer as such but rather an artist who explored the potential of all media, and kept experimenting with new media to create, and often settle into, durable artifacts in various, adventurous materials. As Stephen Walker has discussed in his fine study, Chadwick saw herself primarily not as a photographer or performance artist but as an architectural sculptor.[26] Photography was included in her constructions

because the medium offered her a direct way of making images of materials that were organic, live, often messy; it was a tool equivalent to formaldehyde and forensic pins, as used to preserve specimens by lepidopterists and other scientists. Her choice of blue was connected to the symbolism of heaven and the spaces of reverie and dreams,[27] but more particularly it remembered the cyanotypes of Anna Atkins who, in the 1840s, laid her subjects directly onto paper and exposed them to light. Atkins achieved otherworldly images of seaweed fronds that are progenitors of Chadwick's ribbons and lace (fig.22). Effluvia on the one hand, machines on the other: this was a polarity Chadwick constantly erased, subjecting the rational engines of technology to serving her conception of the cyclical transience and deliquescence.

In the case of *The Oval Court*, a 'huge poster of doves' had caught her eye: 'one dove was white, and one dove was blue and one dove was brown'. It was an advertisement for a new Canon colour copier with different toners. 'It had been in my head that the colour for [*Of Mutability*] had to be blue.'[28] In many ways this is a story that epitomises Chadwick's savvy, her curiosity and daring: the world rushed to meet her wishes and she was not at all daunted by what it took to fulfil them. She rang up Canon and a few days later was offered a machine on very favourable terms. It was set up in her studio in the terraced house in Beck Road, and she began experimenting with making images of flora and fauna - bodies furry and smooth, glistening and matte, including her own. She especially appreciated the directness of this image-making: laying the subject on the glass without any intermediary apparatus. 'It seemed incongruous', she commented, 'to use Hi-tech equipment to produce a place of desire. But I was interested in sabotaging the conventions of business machinery, computer technology, as a way of producing the irrational, states of the feeling, out of it.'[29] The precision of the central focal point, compared to the blur and fade where the object does not touch the plate, pleased her very much: the pores in skin, the ridges in nails, the shine on innards are all registered exactly, while the lack of depth of field gave subjects a dreamy spectral quality. Points on the glass screen of the copier, where her flesh or an animal's fleece or a frond's tendrils were squeezed up against it, intensified the haptic immediacy of the image. The photocopier resembled a mirror that was also a laboratory slide, on which a sample of tissue is smeared (this process would be adopted for her *Viral Landscapes* series three years later).

The twelve figures from *The Oval Court*'s central pool are now housed in a specially made cabinet of their own in a large storage space at the V&A, filled with rolling stacks. The Chadwick plan chest, made of green-coated steel, fourteen drawers in all, contains mostly the exhibited works but also one precious drawing sketching the artist's desired layout for her tableaux. The surrounding works, the barley-sugar columns and the weeping self-portraits, aren't kept in this set of drawers, and of course the counterpoised column, *Carcass*, has vanished from everywhere but the documentary record. Chadwick doesn't seem to have made drawings of her plans for it, or of its brief life on show.

Hana Kaluznick, the V&A's assistant curator of photography, kindly showed me the work when the pandemic had closed the museum's Print Room. We were alone in the grey, windowless, hangar-like space, and as she unbolted each heavy drawer and hauled it open, one at a time, each image swam up white and blue from under acid-free transparent dividers like buried treasure in a funeral chamber – a startling epiphany, like Tutankhamun's gleaming effigy behind the mounds of sand. The work looked pristine and in close up even more astonishing than when I first saw it in the ICA, because visitors were held at a certain distance by the scale of the arrangement as well as the aura of the exhibition.[30]

One by one, lifting off the protective transparent sheets, Hana disclosed each of the twelve collages. I had not remembered how intricately Chadwick had cut up and collaged each figure with her surrounding paraphernalia. Leaning over them to look at them in storage from mere inches away let me see the intensive piecing and patching of every ensemble; thousands of photocopies were scissored and then glued to create the figures. The artist's meticulous attention to every aspect of manufacture means that the jagged edges and seams aren't perceptible from any distance. This concentrated process of assemblage made possible the most striking feature of *The Oval Court*: the dancing, flying, soaring, arching and vaulting of the artist's body. Extended airy twists and arabesques take liberties with the human body while creating a persuasive effect of reality; this is her actual body set down in blue and white as if in a mirror; these are real animals, fishes, birds and insects, but the collage produces impossible poses, distorted anatomies and a dream-like

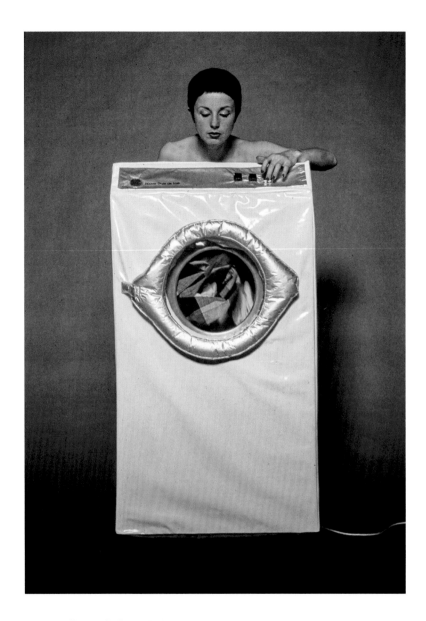

10. Helen Chadwick, *In the Kitchen
(Washing Machine)*, 1977, colour
archival pigment print, image size:
41.9 × 27.7 cm; sheet size: 50.8 × 40.6 cm
© The Estate of Helen Chadwick.
Courtesy RichardSaltoun Gallery,
London

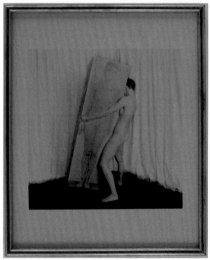

11. Helen Chadwick, *Ego Geometria Sum*, 1983-84. Installation view, Riverside Studios © Leeds Museums & Galleries (Henry Moore Institute archive) and The Estate of Helen Chadwick

12. Helen Chadwick, *The Labours X*, 1986, photograph, gelatine silver print on paper, 76 × 76 cm © Leeds Museums & Galleries (Henry Moore Institute archive) and The Estate of Helen Chadwick

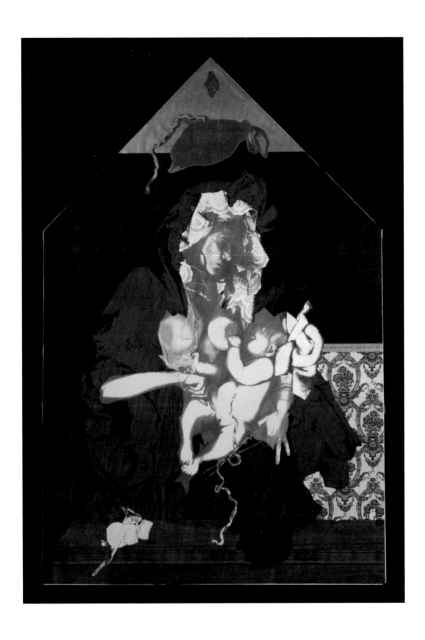

13. Helen Chadwick, *One Flesh*, 1985, collage of photocopies on paper, 168 × 113 cm © The Estate of Helen Chadwick / Victoria and Albert Museum, London

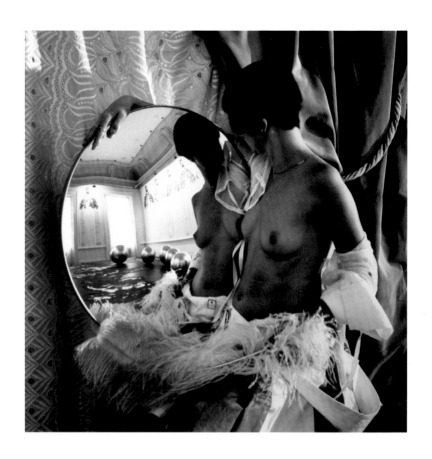

14. Helen Chadwick, *Vanitas II*, 1986,
cibachrome print, © National Portrait
Gallery and The Estate of Helen Chadwick

15. Helen Chadwick, *Loop My Loop*,
1991, cibachrome transparency,
glass, steel, electrical apparatus,
127 × 76 × 15 cm. © The Estate of
Helen Chadwick. Courtesy Richard
Saltoun Gallery, London

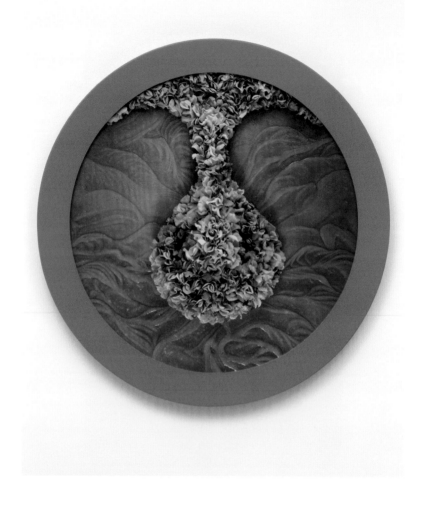

16. Helen Chadwick, *Wreath to Pleasure No 5*, 1992-93, cibachrome print on aluminium faced MDF in a glazed powder coated steel frame, 110 (diameter) × 5 cm. © The Estate of Helen Chadwick. Courtesy Richard Saltoun Gallery, London

17. Helen Chadwick, *Nebula*, 1996,
circular photographs of embryos,
dandelion clocks and eye cataract.
Installation view Body Visual, Barbican
Art Gallery, London; King's College
Hospital, London © The Estate of Helen
Chadwick. Courtesy Richard Saltoun
Gallery, London and Yale Center for
British Art

HELEN 14·5·79

Above:

18. *Helen Chadwick*, polaroid, 14 May
1979. Courtesy and photograph Pete
Smith, from *The Visitors Book* series.

Below:

19. Chadwick's notebook 19 July 2003
© Leeds Museums & Galleries (Henry
Moore Institute archive) and The Estate
of Helen Chadwick

weightlessness. Also, throughout *The Oval Court*, the artist plays with scale to create a promise of blissful partnership between the woman, the lamb, the goose, the starfish, the skate.

However, examining the sheets at closer range than I had ever seen them before, I noticed aspects of the *mise en scène* that I had not fully taken in thirty-five years ago: the artist's face, pressed onto the glass plate of the copier, is distorted, as if in extreme emotion, and the machine's reproduction of skin and nails, the lamb's fleece, the monkfish's anus, captures every pore and crease with hyperreal accuracy that also feels overexact and augmented. In one take, for the figure who is licking and sampling the cluster around her, Chadwick has squashed her tongue onto the plate.

An unflinching grasp of her subjects' flesh remained at the heart of Chadwick's work, sublimated through aesthetic modes to produce beauty. Her visceral approach is particularly startling in relation to *The Oval Court*, because the whirligig of the figures and their ornaments fill the eyes and deflect – at least in my case, back in 1986 – notice from how carnal and raw the imagery is.

In her notebook, the artist labelled the mysterious and powerful figure at due north 'August. Harvest. Fire.' She is facing both ways, Janus-like, has a cavity in her abdomen like an anatomical Venus, and appears to be winding a rough string around a spindle (fig.2). Looking closely, I realised this shaft was the handle of a small axe, its blade scratched and grooved, a tool of cruelty and menace – 'a metaphor of pain', the artist notes. She embodies high summer and the implacable annual cycle: once the harvest is gathered in, winter is not far behind. Then I began to notice, as I looked at the images lying in the drawers, how the motif of cords and ropes and fishing lines recurs, sometimes entangled with ribbons and trimmings of different textures and patterns. Fishing lines end in delicate but lethal hooks, one dangling an oyster as if on a plumbline, and other strings are held taut in the artist's hand, some ending in decorative tassels; in one place a pair of scissors is about to cut through a ribbon: their omnipresence suggests lures, tethers and bonds. A cutthroat razor appears in the *mêlée* around the lamb, a portent of death. The lover with the goose has her face wound in a cloth, as if hooded before execution – the immediate inspiration was Magritte's double portrait *The Lovers* (1929). Again, the sheer hedonist spirit I felt the work exuded began to recede, and the naked figures in the pool came to seem under strain as they sought command of their play and their pleasures. These were not static images, though the medium

could not show them in movement, but nudes in action, each cluster of para-
phernalia an event. In her preparatory notes Chadwick wrote,

> *Self as event not matter.*
> *"At the speed of light, matter mass [one above the other] no longer exists."*
> *"At the speed of light, I no longer exist."*
> *Dissolution of boundaries of self [arrow] the dynamic*
> > *potential*
> > *probability*
> > *pattern.*[31]

Mortality is implicit in the principle of mutability, and already present in the
pool; the artist's alter egos, at the height of bliss, are already facing dissolution.

Chadwick also introduced decay into her Edenic vision, but the blue
depths transformed it into part of the paradise because, as she would go
on to explore in later works, there is beauty to be discovered in matter of
every kind, in every stage of life and death. One figure in the pool dribbles
maggots from the animal viscera in her hands, like a spray of flowers as if
from Botticelli's Zephyr and Flora in *Primavera*; another grasps the fleshy
lattice of a large slab of tripe; one of the water nymphs holds a fistful of
brandlings, or fishing bait (I remember she showed the bucket of them to me
in her studio and told me that they had been delivered by post; she chuckled
over their wriggling, gleaming bodies). Innards would begin to figure more
prominently in her later work, but at the time of *The Oval Court*, she was
already fascinated by ancient oracular practices of inspecting entrails
for omens: she copied an image in a classical dictionary of a haruspex's
engraved liver and underlines 'significant ... were the size, shape, colour, and
marking of the vital organs, especially the livers and gall-bladders of sheep
...'[32] Speaking of *Of Mutability*, Chadwick remarked, 'One way of describing
the image is by listing the things that are in it: figure with goose with entrails
with bandage with maggots with egg-yolk with feathers with shrouded head
... In spilling things on to the plate of the copier so they can act as an oracle of
desire. They don't give clear answers, but cryptic images to interpret as you
will as part of an infinitely-variable self-portrait.'[33]

Her brother, who was working as a shepherd on the South Downs,
brought her a lamb, tied to the back of his motorbike; the lamb had dropped

from natural causes, and Helen decided to prepare it herself, learning as she went how to gut and clean it. Around the figures in the pool, a few bones are also scattered here and there. She was already showing her mastery of complicated emotions, stirring sensations poised between repugnance and attraction, tenderness and cruelty, desire and rejection. She was deft at delivering funny feelings, at creating perturbations, at making you feel all mixed up.

❊

The exuberant excess of *The Oval Court*'s dramatic ensemble struck every visitor as erotic, and the sheer exultant eroticism instigated some of the suspiciousness that surrounded Chadwick: that she was too uncritical about power relations in sex. The poses of the nudes are inspired by high Renaissance paintings such as the enigmatic *Venus, Cupid and Folly* by Agnolo Bronzino, in the National Gallery London: the goddess inspired the exaggerated torsion of one of Chadwick's nudes. She modelled others on scenes of pursuit and rape from Old Masters: Gian Battista Tiepolo's *Apollo and Daphne* (fig.20), Peter Paul Rubens's *Daughters of Leucippus*, Gian Lorenzo Bernini's scandalous Saint Teresa ravished by an angel, and several paintings by François Boucher, including the notorious *Portrait of Marie-Louise O'Murphy* (c. 1752) presenting her rump. Chadwick borrowed avidly, but selectively. These famous works all inspired stretches and twists of Chadwick's self-portraits, but with a crucial difference: Chadwick stripped out the gods and men bent on assault. Instead, her female alters are alone, and their consorts – rabbits and other creatures – are playing with her with every sign of mutual pleasure – though whether an animal can consent is a vexed question. These embraces were also transgressive in their playfulness: the art historian Jennifer Milam has explored images of animal-human contact in the libertine paintings of the eighteenth century,[34] and Chadwick herself passed on a piece of folklore, that 'female skates were known as "fishermen's friends" ... the fishmonger told me, because lonely sailors found the fish was just the right size for them.'[35] Chadwick, however, emphatically neither toys with her beasts nor treats them as pets.

The artist passes her hands through a skate's maw in an act of incorporation, aspiring to attain the power and wildness of the animals, even the more tender species – the rabbits and the lamb. She was clear that she was

exploring female subjectivity, especially in relation to her own experiences of desire. Reading deeply in optics, she found inspiration in Victor Burgin's rejection of classical perspective, which gives optical space precedence over psychical space – or, in Chadwick's terms, 'the reflexive domain of introspection'.[36] She responded to Burgin's call for a shifting of the angle of view, dispensing with classical perspective by adopting a multiplicity of viewpoints. The artist herself is present in the images, but also the object of a dispersed spectator. She floats above herself in the space, and her self-portraits eschew altogether the eye-to-eye scrutiny of the humanist tradition.

Chadwick describes each of the twelve events we see in the pool as:

> *an exploration for me of some kind of physical sensation, or some aspect of desire. So I used my body to make them directly; so they're partly autobiographical, but they're also great fictions ... They are also very much a way of picturing something you can't see, because it's to do with an impulse, something internal.*[37]

These 'great fictions' are indebted to iconographic tradition, especially allegory. Chadwick, searching for a fresh aesthetic order, to be articulated in a female voice, turns to Renaissance *imprese*, or emblems, embodying ideas, as she moves between realistic portraiture (actual prints of her own flesh) towards elusive poetic signs, as in a modernist text, where the meaning is labile and the purpose ambiguous. The humanist *impresa* is often centred on an allegorical female surrounded by attributes that define her role, often part of a cluster. Chadwick's ring of nymphs nods towards cycles such as the Seven Liberal Arts, the Seven Deadly Sins, the Months, Arts and Sciences, or the Continents and the Planets (as on a ceiling painting by Giovanni Battista Tiepolo, one of Chadwick's lodestars). These are compressed, cryptic symbolic images, which usually convey a moral purpose (as indeed does Chadwick's *Of Mutability*, though the morality is slyly posturing). A series of engravings of the Vices and Virtues, for example, by the sixteenth-century German 'Little Master' engraver Heinrich Aldegraver (d. 1558/61) creates bizarre conjunctions of half-draped female figures with symbolic animals (a camel with Luxuria (lust, fig.21), a bear with Ira (Wrath)). To take another example from the same period, a sequence of elaborate Vanitas still life paintings by Joachim Beuckelaer, now in the National Gallery, London, warns of

false pleasures but, according to the paintings' titles, also represent *The Four Elements* (1569/70, fig.37).

Chadwick kept notes of 'the lost language of attributes and symbols' but, as a twentieth-century artist, she rejected fixed interpretation or overt moralising. Whereas Pietro da Cortona on the Barberini Palace ceiling painted his ring of female virtues joined together by the huge laurel wreath they are carrying (fig.23), Chadwick's flora and fauna seem to explode around each figure in her solitude. Her fictions are enigmas.

As I saw the figures rise like Lazarus from the plan chest in which they now lie, I felt the complexity of their eroticism, which avows troubled feelings within the very ecstasy and heights of pleasure.

'Yours in rocaille...'

Two years before the ICA show, in 1984, Helen Chadwick visited the V&A's glorious survey exhibition, 'Rococo: Art and Design in Hogarth's England'; it sparked her passion for the style.[38] The show was huge and eclectic, covering – as is only proper in a museum of the V&A's range – multiple media and applied arts. It included a section on textiles and featured glowingly the work of Anna Maria Garthwaite, a Spitalfields silk-weaver who established on her own a thriving independent business, designing fabrics and wallpapers and dresses in the most sumptuous rococo style; she published two collections of samples a year in beautiful pattern books (fig.24–25).[39] Garthwaite presented Chadwick with an exceptionally sympathetic forerunner, for the Spitalfields artist combined heightened skills, gorgeous and sensuous ornament, botanical imagery, prolific production and supreme efficiency in executing her visions. As it happened, the two women's destinies would be strangely wound together.

Alison Turnbull remembers Helen's love of all patterns and, in relation to some paisley fabric she was admiring, how she exclaimed, 'Wouldn't it be wonderful to invent a new form, a new pattern!'[40] In effect, this is what she was attempting throughout her life, and the decorative language of rococo placed a new exuberant language of pattern in her hands. Fired up by the exhibition, Helen and her partner Phil Stanley, an architect, went on a tour of the pilgrimage churches and other Baroque architectural sites in Germany and Austria. The trip was an epiphany: the sites' rococo style transformed the artist's work from then onwards. 'They are constructed fantasies' she wrote,

> *where the autocratic lineal architectural space breaks down and becomes dissolute and organic ... It's pleasurable space, sensual space. I respect Modernism ... but there's a repression there. And it is that repressing that I have a resistance to. I admire the dynamism of these spaces, and this brings us back to the organic, and the organic as something that encompasses the corporeal and the imaginary.*[41]

The Oval Court consciously reprises the sinuosities, the materials, the palette, and the whole sensory stimulus of such buildings as the Amalienburg, a small hunting lodge designed by François de Cuvilliés in the grounds of the Nymphenburg Palace in Munich. It is a bauble, a jewel casket of an edifice,

scaled up to allow princes to circulate inside; it consists of a cabinet lined with blue and white porcelain and a hall of mirrors, framed in azure and silver, the reflections shimmering and scintillating into infinite recession and creating an overall impression of a subaqueous other world (fig.26).

In the neighbouring Alps, the artist responded passionately to the monastery church of Die Wies, where the imagery focussed on the image of Christ's tears (fig.28). She found the interior to be like snow, clouds, ice-cream, candy floss – 'rocaille as snow', she noted, 'melting spirit, allegory of spiritual love/ thaw'.[42] In Munich, she also admired the interior of the Theatine Church, austere in its immaculate whiteness but extravagantly gilded and decorated. Her archives contain scores of photographs she took: of the Cuvilliés theatre in Munich, of exquisite sleighs in the Residenz Ludwig Linderhoff in Bavaria, of waxworks souls burning in purgatory.

Catholic baroque in the High Renaissance had pushed architecture to the limits of airborne suspension in an era before digital modelling and steel: Borromini in Rome experimented daringly with parabolas and ellipses. These achievements lay at the foundation of the dizzy fantasies of eighteenth-century rococo. Baroque is usually credited with disrupting classical norms, by displacing the keystone from an arch, breaking through a dome to the sky above, perching figures on parapets and twisting columns – all architectural innovations that entered Chadwick's visual lexicon. However, the style did not only overstep previous conventions; it united the ideal harmonies of classicism with new rhythms and forms in order to shape a new beauty.

Inspiration for these new aesthetic criteria came from two dominant sources: irregular, natural forms (vines, palm trees, acanthus leaves, pomegranates, rock formations – and, indeed, grottoes) as recur everywhere in Roman ornament, and the arabesque or sinuous line as also found everywhere in Roman decoration and then elaborated in Islamic art (as its name remembers). Chadwick was enthralled by this aesthetic conjunction of utopian geometries and natural foison, but the German sites she explored added a particular quality of flight to the baroque style she was to adopt. Rococo had moved from churches to embellish secular spaces of delight – the palace, the hunting lodge, the boudoir, the bedroom, the garden pavilion, the folly (Bernini's *Baldacchino* is a variation on a pavilion). Secularising the grand style of Roman architectural baroque, rococo also turned it in an unreservedly frivolous direction without apology or anxiety. This was

sensuousness in a spirit of light-hearted bliss – the quality Italo Calvino praised as *leggerezza*, lightness, in his *Six Memos for the Next Millennium* (1988), and which Chadwick found in the *ancien régime* mode of Rococo.[43]

The hedonism of the style offered a sincere celebration of creation; the eighteenth century's cult of reason gave pleasure a role in *le gai savoir*, in *douceur de vivre*, and accepted it as a principle as well as an aim of beauty. Its dominant exponents – Fragonard and Boucher – created many flirtatious and libertine pictures for their patrons, but their enlightenment morality still ballasts the allegorical meanings they also attached to them; this aspect too became central to Chadwick's many variations on the nude.

The word rococo strikes an echo with ba*roque*, but apart from the allusion to rock the suggested origins of the words are various, the Oxford English Dictionary stating it was first used by jewellers to describe irregular pearls.[44] Rococo artists and designers sought out eccentric forms and extended the repertory of beautiful *naturalia* to rare materials and bizarre, even grotesque excrescences, as in grottoes. They imitated rock formations and shells in furnishings and ornaments, and *rocaille* became the fashion. Influenced by the cultures being conquered by European nations, which expropriated those colonies' natural wealth, European artists in various genres were beginning to explore more materials such as fine-grained or knubbled woods, tortoiseshell, feathers, coral, pearl and mother of pearl, amber, ivories (tusks of narwhals and boars, as well as elephants), alongside gems, silver and gold. These often rare organic materials defy boundaries between animal, vegetable and mineral. The category of *naturalia* merges with *artificialia*: nature herself becomes an artificer, like the artist-craftsworkers, the *homo faber* or *mulier faber* engaged in making the artifacts.

This aspect of the rococo aesthetic suffuses Chadwick's vision in *The Oval Court*, where bodies, nudes, creatures, flora and greenery are metamorphosing into artifacts alongside the accessories – the jewellery and lingerie the artist is wearing. The starfish appears like a brooch rather than a living creature, the oyster has become a pendant, even the drift of innards seems like a scattering of gems. Through the blue and white photocopied images and the intense detailing of the collages, the artist is producing a series of transformations of nature in the spirit of eighteenth-century rococo, and the empathy she felt with what she had seen in Germany can be felt in the postcard she wrote to Chris Titterington, a friend who was then Assistant

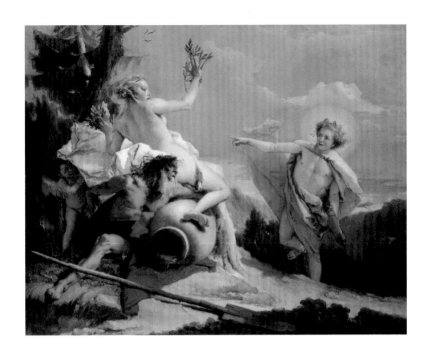

20. Giovanni Battista Tiepolo,
Apollo Pursuing Daphne,
c.1755-60, oil on canvas,
68.5 × 87cm. Samuel H. Kress
Collection, National Gallery
of Art, Washington, USA

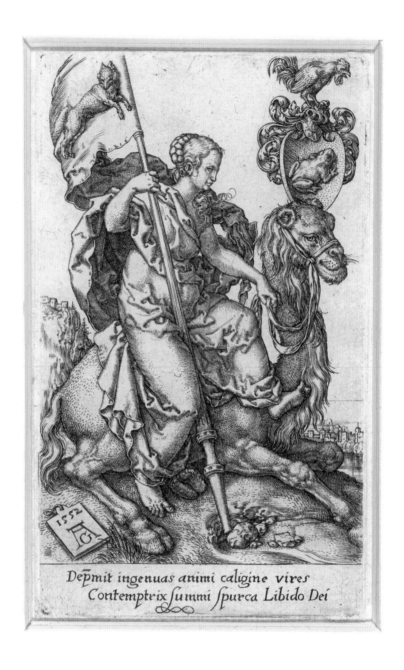

Dēmit ingenuas animi caligine vires
Contemptrix summi spurca Libido Dei

21. Heinrich Aldegrever, *Lust*, 1552,
engraving, 10 × 6 cm. Rijksmuseum,
Amsterdam

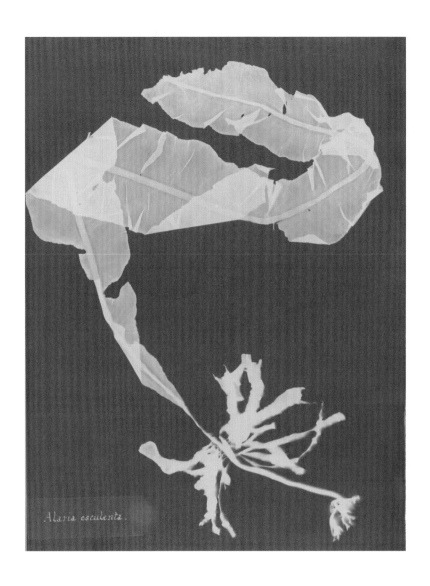

Alaria esculenta.

22. Anna Atkins, *Photographs of British algae: cyanotype impressions*, 1849-50. Spencer Collection, The New York Public Library.

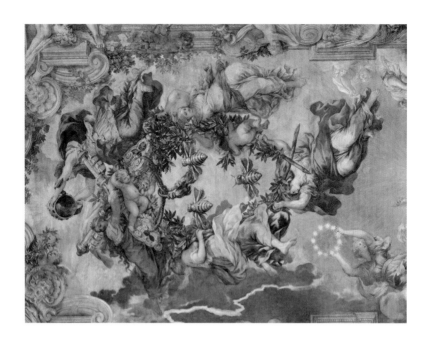

23. Pietro da Cortona, *Allegory of Divine
Providence and Barberini Power*, 1633-1639,
detail of ceiling fresco, Palace Barberini,
Rome. Courtesy Gallerie Nazionali di Arte
Antica, MIC - Bibliotheca Hertziana,
Istituto Max Planck for the History of Art/
Enrico Fontolan.

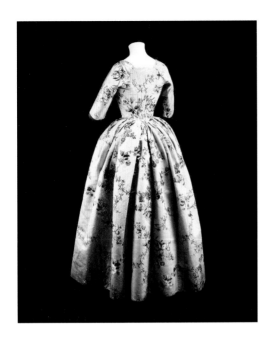

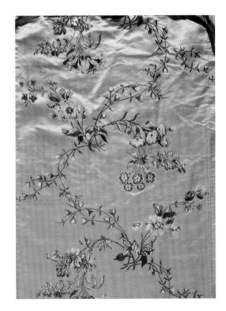

24-25. Anna Maria Garthwaite, Gown, 1740s (made), 1780s (altered), Brocaded satin in coloured silks, Given by Mrs Olive Furnivall, © Victoria and Albert Museum. London.

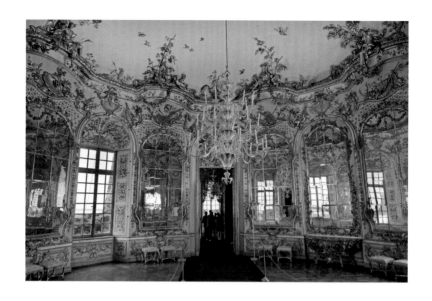

Above:
26. François de Cuvilliés (lead designer/court architect), Johann Baptist Zimmerman (stuccoist), Johan Joachim Dietrich (woodcarver) and Lauro Bigarello (gilder), Spiegelsaal of Amalienburg, 1734-39, Nymphenburg Park, Munich. Photo: Allie Caulfield

Below:
27. Carl Albert von Lespiliez and François de Cuvilliés, *Cartouche with Hunting Motifs,* from *Livre nouveau de morceaux de fantaisie [New Book of Fantasy Pieces],* 1738-45, bound print, engraving, 39.2 × 25.1 cm. Cooper Hewitt, Smithsonian Design Museum

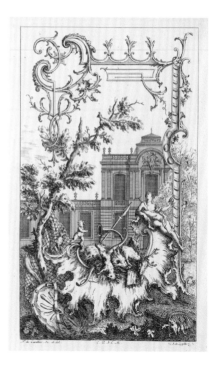

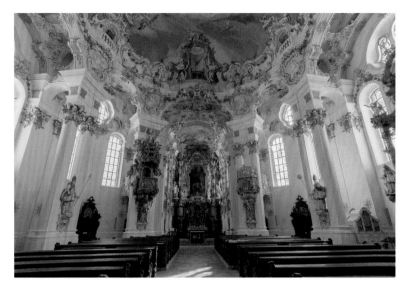

Above:
28. Pilgrimage Church of Wies, Bavaria

Below:
29. François Boucher, *Léda*, from
*Nouveaux morceaux pour des paravents
[New Concepts for Screens]*, 1740,
etching, 50.8 × 26.2cm. Cooper Hewitt,
Smithsonian Design Museum

Left:
30. François Boucher, *The Arts And Sciences: Architecture and Chemistry* c.1760, oil on canvas, 217.2 × 77.5cm. Henry Clay Frick Bequest © The Frick Collection

Right:
31. François Boucher, *The Arts And Sciences: Astronomy and Hydraulics*, c.1760, oil on canvas, 217.2 × 96.5cm. Henry Clay Frick Bequest © The Frick Collection

Curator of Photographs at the V&A. The postcard showed the Hall of Mirrors in the Amalienburg, and Chadwick used a silver pen to express her passionate enthusiasm for what she had seen, signing off, 'yours in Rocaille'.[45]

Rocaille invites appreciation for natural irregularities, even monstrous excrescences; it bears a relationship to classical auricular ornament, which, as the word suggests, draws on the involutions of ears: Chadwick's 1988 piece, *Ecce*, a rococo emblem, indeed puns on a human ear and a rococo cartouche.[46] Rocaille – and its parent rococo – is fundamentally fantastical and seeks out the singular; it is anti-Euclidian, anti-Platonic, anti-Palladian. It embraces every intricate asymmetrical formation that occurs in vegetation and natural materials, such as fungi and fur. In order to set off its syncopated visual rhythms even more sharply, artists include regular architectural elements in contrast. For example, in the series of prints in his *Livre nouveau de morceaux de fantaisie* (*New Book of Fantasy Pieces*, 1752–54), Cuvilliés extemporises in the foreground on shells, fronds and rocks, gnarled and dying trees, and doodles fanciful airy arabesques while always including in the background a classical edifice – a pyramid, a palace, a temple (fig.27). François Boucher made a similar series of prints, *Nouveaux Morceaux pour des paravents* (*New Concepts for Screens*, 1740) in which he yokes together a sense of erotic energy with the profusion of twisted and intertangled forms, as in the design entitled 'The Triumph of Priapus' and another showing Leda and the Swan clasped together on top of an extravagantly burgeoning rocaille fountain (fig.29).

Unlikely as it seems, Chadwick recognised in this late eighteenth-century princely style a love of unfettered desire and self-gratification which she wanted to express. She also incorporated those formal, ideal geometrical elements to accompany the hotter energies of the natural bodies: the gilded spheres and the spare glass column of *Carcass*. But unlike Cuvilliés and Boucher, who subordinated classical harmony to the riot of rococo, Chadwick in *Of Mutability* is deliberately attempting a fusion of them, along lines that would run through all her subsequent work. The classical forms imply reason and the natural forms instinct, unreason. In Chadwick's oeuvre, she shows herself powerfully attracted by both. This tendency to reconcile opposites guided her early choices to study science subjects. The fascination with empirical discovery on the one hand, and with anarchic mess on the other, consistently shapes her work. She mentions in her conversation with Mark Haworth-

Booth how she loved studying mechanics; in another conversation with me she remembered the toy microscope she had as a child, and how she adored using it to examine her finds. As a sculptor her vision was architectural, and her installations theatrical as a set design. Enlightenment rococo showed her a way to search for beauty in the encounter between science and nature.

Boucher's designs for an elaborate ceiling, decorated with allegories of Arts and Sciences include La Méchanique, a draped female figure holding a set square in one hand and computational tables in the other, with a vast pile of scaffolding behind her and a pulley-and-chain lifting device to her left.[47] Even closer to Chadwick's concerns are the decorative panels Boucher painted for Madame de Pompadour's boudoir. Also depicting the arts and sciences, the artist here replaced the usual female allegories with small children, who are shown busily practising architecture and chemistry, astronomy and hydraulics (fig.30–31) among other more familiar arts (painting, sculpture). The whole room has been transported to the Frick Museum in New York, and very beguiling it is too. But if you look past the feast of colour and playfulness, it is possible to feel how the dream of the age of reason - that deep knowledge - must be cultivated in all spheres for true pleasure to be attained. The idea saturates this aristocratic, feminine *jeu d'esprit*.

The nude, the gaze, and the self

The ensemble of the ICA installation in 1986 was audacious, even flagrantly defiant. Looking back a few years later, Chadwick remarked, 'I was nearly massacred in the mid-80s for presenting the female body naked.'[48] The show provoked perceptive admiration from Richard Cork,[49] as well as from James Hall and Waldemar Januszczak, but the critics also showed puzzlement. William Feaver praised it in the *Observer*, though with a touch of condescension (Chadwick showed 'pretty wit').[50] The aesthetic was unusual, the imagery unfamiliar, the whole conception philosophically arcane to many. But for some critics, Chadwick's embrace of luxurious beauty in the idiom of the eighteenth century, far from resisting repression, exuded decadence and a suspect affinity with the *ancien régime*, its inequalities, its sexual exploitation of women of all classes, most especially the poor, of whom there were very many. The display of nudity in a key of erotic rapture also disturbed those theorists of female emancipation who were reconfiguring the woman artist as one whose gaze looks out at the world, explores and defines what she sees, and rejects the spectacle of her own naked and desirable body. There were rumblings about the artist betraying feminist principles by displaying herself so enticingly, thereby pandering to 'culturally overdetermined scopophilia', and in particular the male gaze.[51] Marjorie Allthorpe-Guyton, writing in *Art Monthly*, noted that admiring critics were male and was reproving:

> [T]his new work flies in the face of much recent feminist thought ... Of Mutability *is not conceptually coherent; it is deeply ambiguous and whatever the artist intended it can be misread ...*
>
> *Helen Chadwick appropriates male fantasy through quotation ... but parody is a dangerous strategy when it becomes a simulacrum ... [her] seduction by the instant image denies the work the possibility of achieving the 'narcissian' self-portrait she intended. Instead, we have a* masquerade *of femininity.*[52]

The skittish vignette of the artist presenting her bottom to a floating feather, to which I alluded in my catalogue essay, provoked Allthorpe-Guyton's particular disapproval: 'that ticklish feather is surely but a prelude?'[53] She left the question hanging.

The most thoughtful critic was Michael Newman, who found himself

questioning his position as a male observer and the difficulty for a woman artist to escape the coils that conventional forms of representation throw around her:

> *The discourse of the subject within which Chadwick's art takes place is a post-romantic, post-modernist discourse. The problem for any such discourse is that its constituents are necessarily traditional: it seeks to make new utterances by referring to conventional codes (which are implicated in that which it seeks to criticise). Hence the necessity of deconstruction ... which enables historical reference to serve more than revivalism.*[54]

Although Newman is wrestling with the work, he misses the sheer transgressiveness of Chadwick's choice of rococo and the boldness of this move. By embracing a traditional aesthetic associated with the decorative arts, many of them having been historically practised by women, she was once more seizing on a derided category, and transvaluing it, just as she consistently inverted traditional responses of dismissal, disgust and repulsion aroused by the leaky and unruly bodies of women. It is counterintuitive that rococo could be cast as an undervalued minority taste when it is predominantly associated with Marie Antoinette and her ladies-in-waiting playing at shepherdesses. But Chadwick sees past the manifestly elite clientele of the style, and the immediate beautiful shimmer of the artifacts, to seize hold of an inner principle of femininity that she was bent on consecrating: in her hands, rococo dynamics would express the generativity and efflorescence of a newly configured relation between nature and women's bodies.[55] She developed a strong rebuttal to the criticisms. In an interview in the women's art magazine *Make*, she was combative: 'I used the body to explode ideology. Feminism was arguing that you shouldn't see the naked female body. I disagreed... I was looking for a way of creating a vocabulary for desire where I was the subject, the object, and the author ... rather than trying to see the female as a desired object, you had to see yourself as a desiring subject.'[56] Later, in 1995, she asserted, 'I think [*Of Mutability*] hymns the deviant and the deceitful.'[57]

Chadwick's ceaseless pursuit of beauty, through fresh uses of canonical forms and traditional motifs, was spurred on by a desire to reassign status to arts and crafts that were considered lesser – dismissed as ornamental.

This motive was feminist in spirit and shared by several women artists at the time, and even more significantly since. Chadwick valued the applied arts – textiles, dressmaking, napery, hosiery, corsetry, embroidery, pottery, china, glassware, plucking fowl and dressing animals – because many of these domestic skills, essential to human society, were often women's expertise.[58] In comparison with the fine arts, these skills inspired condescension because they invoked direct, haptic experience, relying on the knowledge delivered by touch, smell and, even, taste. Chadwick had a different, independent sensorium and she wanted from the start (she made naughty genital prostheses for her early work *Domestic Sanitation!*) to break the rules of social and artistic taste. Many of her subsequent works continued to retrieve ornaments of the past to set off her exhibits of curious new beauty, as she bent and stretched accepted definitions of female gender and brought down barriers against pollution and death.

Of Mutability expressed a concept of sex, female gender and social possibility that came to define third wave feminism. The American 'pro-sex' radical and essayist Ellen Willis was arguing in the 1980s for an ecstatic sexuality, inspired by the psychoanalyst Wilhelm Reich, against the so-called 'authoritarian moralism' adopted by anti-pornography campaigners in the feminist movement. She urged her readers 'to start considering women as empowered sexual agents ... without being told they [are] colluding in their own oppression.'[59] Interestingly, Chadwick, while aligning herself clearly with these claims to women's freedoms of body and spirit, always runs a current of melancholy through her work. As an artist, she doesn't make pronouncements as in a manifesto, but reflects in light and shade. When Allthorpe-Guyton sent the artist a copy of her review in draft, Chadwick noted in the margin, beside the charge that the work was ambiguous, 'How could it be otherwise?'

'I Am Geometry...'

Memory, as flesh into form... turning the past, my body, into Form, Number, Divinity.
– Helen Chadwick[60]

Chadwick had already drawn fire from the mainstream feminist wing on account of her self-presentation in *Ego Geometria Sum* (1983–86), a multi-part sculptural installation for which she photographed herself naked from multiple angles, keeping her face hidden. This iconography provoked rebukes: she was reifying the female body, denying individual presence in the worst allegorical mode, and, the reproach ran, also offering her (delectable) nudity to the observer, an implied desirous male.[61] Needless to say, Chadwick defended herself eloquently on these counts, as she would continue to do throughout her subsequent work. Her contentiousness was later underlined, for example, in the show *Bad Girls* (1993) where her fellow artists included Nan Goldin and Sue Williams. Writing in the catalogue, Laura Cottingham expressed a widespread sense of discomfort when she defended the work of these artists: 'But in as much as it is different from, and even contrary to, the strategies and aims of the 70s Feminist Art Movement, this work is part of that movement's legacy.'[62]

Chadwick was feeling out a way to tell her life story and make herself a subject through fresh female iconography. In notes about the work, she quotes Lucretius: 'Experience is composed of material objects and the space in which they move, which is the absence of material objects'. To this she adds, 'I felt that absence was where the self might be.'[63] She therefore superimposed her adult self on the objects, each of them a site of memory, projecting on to them photographs of herself, naked and curled up foetally in the incubator where she was kept as a premature baby, lying in her pram, sleeping in her childhood bed, hiding inside in a small wigwam as a child in Croydon, playing an upright piano, leaping over a gym horse and, finally, holding up the front door of the house in Beck Road, Hackney which she had managed to acquire as part of an ACME Housing scheme (with a group of friends, she had persuaded the borough to support their claim).[64] In the process of creating the piece, she had also made trials with a photo of the Parthenon (a tribute to her mother, who was born in Athens), a soft toy from

childhood and, significantly, her school geometry set – but not, surprisingly, the toy microscope with which she had played with so much delight. As she chronicled specific circumstances of her life's journey, she enclosed each memory in a geometrical solid, including Euclidian fundamentals (octagon, oblong, cube and pyramid, fig.11). The photographs were printed on the ten wooden blocks with a technique specially devised for the purpose: eventually, after several trials, she coated the plywood surface with a photo-sensitive emulsion, on which she was able to produce the images. The effect is eerie: the photographs do not lie on the surface but are consubstantial with the wooden medium, closer in effect to a daguerreotype than a print; they seem to be haunting the solid forms three-dimensionally, as if emanating from their interior.

The whole dramatic installation meditates on home and environment and the necessity of place to identity and belonging, setting out an autobiography in terms that have become conventional today but were highly unusual then; the success of her experiments also showed what a consummate craftworker Chadwick was and how adventurous she would continue to be in her use of media and materials.

These sites of identity correspond to *femme maisons* (woman/wife homes), to adopt Louise Bourgeois's inspired title for works that ironise the condition of the *housewife*, by conflating her own body with her house, her hearth, her role as a homemaker. In the 1980s, Bourgeois was known principally to a New York circle and had not attained the huge renown she enjoys today. It is not clear how well Chadwick knew her work, but the younger artist was certainly thinking consciously of herself as a female subject along lines that resonate with Bourgeois' struggles. Chadwick, in keeping with the more pragmatic, less oneiric axioms of British feminism in the post-war period, explored empirical conditions more intently than Bourgeois, who was influenced above all by Carl Jung. The sense of female contingency, however, runs through both artists' vision.

The tone of *Ego Geometria Sum* was mock-heroic, combining a determined annexation of male iconography (Hercules, bodybuilding, naturist idealism) with a deliberately overblown theatricality: the framed photographs were hung against a backdrop of peachy-gold drapes. Chadwick often undercut her own flights of aesthetic daring with a wit that is Surrealist in character: the Labours defy masculine supremacy (a little female person like

me can do this too!) and at the same time point out its absurdity (fig.12). She was quoting from popular media and parodying conventional pieties: her treatment of nudist and weightlifting magazines echoes, for example, the parodic strategy of Max Ernst in his collage books, such as *La Femme 100 Têtes* (*The Hundred Headless Woman*, 1929), for which he cut up religious and medical illustrations to explode the originals' underlying principles. Transgression, sabotage, subversion and perturbation were his motives as a Surrealist – he called perturbation 'ma soeur' (my sister) in a series of works. 'Perturbation' also catches Chadwick's saboteur acts of mischief and perversity, as she embarked on reconfiguring the aesthetic of pleasure in order ultimately to change the relationship between the public and its expectation of what a woman artist can do.

Daring to break with received ideas marked her out all her life, and she was looking to precursors as well as to work by her contemporaries. In the sustained interview with Haworth-Booth, Chadwick mentions several contemporary artists who were similarly exploring the condition of being a woman through examining their own bodies, using their own material nudity to establish nakedness as a fresh, unflinching form of truth-telling. 'Nuda Veritas' (naked truth) was a Renaissance allegorical commonplace: Truth was personified as a classical female nude because truth has nothing to hide. The root of *aletheia*, the word for 'truth' in Greek, comes from *lethe*, forgetfulness, with the privative a-, as in a-theist: truth does not forget or cover up. Rebellious, driven, imaginative artists at the vanguard of feminist representation in the 1970s and 80s seized this trope and shook it into deliberate, shocking provocations.

The novel *How Should a Person Be?* (2010), by the Canadian writer Sheila Heti, struck a chord with thousands of readers: the narrator – herself, as this is a vivid instance of auto-fiction – looks to an older friend, a woman artist, observing her in order to diagnose how she manages to succeed in her relationships, her creativity, her life. The author tries out selves in relation to her chosen role model, whom she emulates in a kind of fan's ruthless crush. The mimetic tendency and the need to triangulate the self by taking cues from another as one negotiates new experiences in the world have been under-explored in feminism, I feel, even though women read women's magazines and follow women exemplars – and influencers – as they learn to present themselves.

Chadwick was intensely curious and absorptive, and she had a gift of serendipity – landing on the inspiring text, the crucial artifact. She was for example looking carefully at the Northern Irish artist Roberta Graham, especially a light-box work, *Life Sighs in Sleep* (1983). In a catalogue essay on the piece by Gray Watson, Chadwick underlines, 'The most character-istic quality of the sacred is transgression.'[65] In her determination to forge a female language in art, she needed to defy those boundaries that held purity from danger, and she found her method in sacrilegious uses of the body. She salutes the work of Judy Clark, an English artist who 'catalogued in a very formal way bodily ephemera … the detritus of the body' (fig.33). Clark rubbed graphite on sections of skin and made fingerprints, as it were, of herself and friends.[66] In the same period, Penny Slinger was creating elaborate photomontages of herself, flouting rules of feminine decorum and advocating, in a carnivalesque spirit, a commitment to the good of eros and women's autonomy in sex (fig.34). This fellow artist shared Chadwick's interests and saw her work with her own body as part of the key struggle against the phallic symbolic order, based on absolute sexual difference.

During the period in which Chadwick was embarking on *Of Mutability*, the first wave of admiration was building for Frida Kahlo, the Mexican painter and radical who wove her self-image into a visual autobiographical performance. In 1982, Laura Mulvey and Peter Wollen curated a remark-able show at the Whitechapel Art Gallery about Kahlo's friendship with the photographer Tina Modotti; two years later, they turned this into a poetic and influential documentary film. Chadwick herself would follow their lead when she presented a sumptuously sensual programme about Kahlo for BBC2 in 1992.[67] Chadwick was also an admirer of Jo Spence, another inven-tive self-portraitist, who chronicled her life under the title *Putting Myself in the Picture* (1986).[68] Spence combines documentary imagery of her own life with performance and fantasy: in the practice of photographic therapy she developed with Rosy Martin, she took herself back to babyhood, teenage, and so forth, staging critical experiences of being fed, dressing up for a party, sex. Later, when she was suffering from breast cancer, Spence continued to examine herself before the camera and the viewer, unsparingly. Spence thereby combined realist feminist activism with fantasy projections; she protested against the beauty industry, sexual dependency, the idealisation of motherhood, the enslavement of housework, but she infused the images with

her private, subjective fantasies which owned up to profound ambivalence – she was powerfully attracted to the very states of subjugation she was consciously rejecting. For a film about the fairy tale Cinderella, which I made for the BBC Arena programme, Jo Spence dressed up in the sparkly costume of a fairy godmother holding a wand and spoke about her ferociously contradictory feelings about the rags-to-riches fairy tale and the pervasive propaganda uses of beauty rewarded (fig.35). This was before disasters overtook Princess Diana, the 'people's princess'.[69]

Chadwick's earliest known works also tackle head on issues of women's subjugation with a similar political incisiveness: for her degree show at Brighton Polytechnic she made costumes to be worn by the performers ('Pre punk erotic artefacts, quite glamorous but with a disturbing edge'). 'The Crotch' and 'The Armpit' (1973-74), and 'Quilted Abdomen' (1975) were made of satin, fur, and kapok; the artist also embroidered pink satin aprons and bras and knickers, simulating vulva and labia and breasts, with fluff and feathers appliquéd for pubic hair.[70] In a similar vein, *In the Kitchen* (1977) was made during Chadwick's student days at Chelsea School of Art. For these elaborate sculptural installations-cum-performances, the artist drew in friends and colleagues: she created Oldenburg-like inflatable plastic household white goods– stoves, fridges, washing machines (fig.10) – and invited friends to perform inside them alongside her – again these became *femme maisons*.[71] These works, which survive only in photographs and film footage, revolt against female domestic servitude, in a punk mood of irreverence laced with anger. *Train of Thought* (1978) began as a performance and was then printed as a *fotonovela* or romance magazine, which tracks the discomfort and helplessness of a woman on the London underground after a man takes the seat beside her and keeps encroaching, touching her – deliberately? Unconsciously? It's a startlingly far-seeing blast about the dangers of public space and the need for women's safe places.

Regrettably, I did not know the early performance pieces, and Helen did not bring them up in connection to *The Oval Court*. They are remarkably original, hard-hitting, ironic contributions to feminist debates of the time. If visitors had known of them, the response to Chadwick's uses of the nude would have been greatly affected, and some of the initial suspicion of her work lessened, I believe.

Of Mutability recognisably continued the artist's glee in flouting con-

ventional codes of artistic and feminine propriety, but the raucousness and prankishness yielded to a passion for an earlier rococo erotic and domestic aesthetic. It is significant that Angela Carter, a contemporary of Chadwick's, likewise grounded her form of feminist provocations in the rational enlightenment, set many of her re-imagined fairy tales in a pleasure-loving eighteenth century, and wrote a dazzling essay on pornography, *The Sadeian Woman* (1979), arguing for the Marquis de Sade as a true critic of female servitude, rather than its most notorious proponent. However, unlike Carter, Chadwick was not contentious on account of her philosophical libertinism, but rather because she loved the era's insouciant surrender to the pleasure of decorative display.

<p align="center">❋</p>

I first met Helen Chadwick in person in 1985 at the show of *Ego Geometria Sum* at the Riverside Studios. We had arranged to meet there to discuss her taking part in a documentary film about women artists and their use of the female form. I was with Gina Newson, the director of the programme, which was commissioned by Channel Four, and eventually went out in 1986 under the title *Imaginary Women*. Helen was invited to join an onscreen 'dinner party' staged in homage to Judy Chicago's notorious installation of 1979, which celebrated thirty-nine foremothers and rendered each of them as a customised plate decorated with symbolic imagery, often explicitly sexual. Among the other guests were Susan Hiller, Rose Garrard and Kate Blacker; I was the host, trying to keep the conversation on track. The arguments before us arose from *Monuments & Maidens: The Allegory of the Female Form* (1985), which I had just published. In this book, I ask why Liberty and Justice, and any number of other concepts – including nations, arts, sciences, manufactures – should be represented as female in traditional iconography. From the Greeks' imagery of cities and Christian virtues, to nineteenth-century celebrations of new inventions and technologies ('Electricity' appears in some French *mairies* as a half-clad nymph), the female form has been annexed to express ideals and other abstractions. Alongside many feminists of my generation, I demanded that women artists occupy these sites of meaning and make them their own. Newly embodied, they would then speak in their own voices from their experience and endow the abstractions with consciousness. Rose Garrard had enjoyed resounding success for her series

of self-portraits re-investing personal meaning into figures such as Pandora, the first woman of Greek mythology, who, like Eve, was blamed for the fall of humanity. Susan Hiller had disrupted one convention after another in the tradition of female self-presentation, for example with a sequence of timed photographs of her pregnant body; she was also experimenting with alternative portraiture through handwriting, and, like Chadwick, with photobooth snapshots.

The discussion was to follow the ancient model of the Symposium: each artist had her turn to speak, and the others were to comment. When we turned to Helen Chadwick, she was challenged for not showing sufficient resistance to dominant conventions around female nudity, for displaying herself naked and apparently soliciting the male gaze. At one point, after Helen had hotly defended her self-presentations, Susan Hiller quipped, 'But you do look kinda cute.'

The film is now a curio, but it has historical value as a record of the struggle of women artists to be heard and valued. Such an assembly is no longer exceptional or marginalised and consequently women who make art are not as defensive as they – we – were then. But above all, the principle of self-creation through performance and autobiographical self-portraiture, as pursued by Frida Kahlo or Jo Spence, has become a fundamental process in the arts (not only the visual arts) and has spread throughout public communications and social media.

In the artist's studio, 1985

Both *Ego Geometria Sum* and *Of Mutability* are acts of autobiography but, while the first is retrospective, the second is visionary and prospective. Both pitch into the arena of discussion motifs that blaze in Chadwick's work: the presentation of the self, most especially in the nude fine art tradition; the question of ideal geometry and its relation to traditions of harmony and beauty; the centrality of the senses and the sensual; the role of ordinary stuff in a person's experience, and its preciousness, no matter how degraded or banal. Both these large-scale works of art are shot through with similar ambiguities, in the strict sense of double meanings. In both, Chadwick absorbed the principles of a tradition in order to question them, and annexed technology to support her scepticism: for example, the machines she adopted as her tools undermined the cult of the individual artistic mark, effacing painterly textures and colour and deliberately 'cooling' the riot of flesh in a Rubens or a Boucher by using a cutting-edge business machine. She wrote in her notes that *Of Mutability* was to be a 'complete reversal' of her earlier, major act of self-portraiture, 'from rational to irrational, truth to fiction, eternity to ephemerality, determinism to deviation, divinity to mortality, immutable to change, purity to corruption, spirit to sensation, classical to rococo ... Before I was bounded, now I've begun to leak...'[72] The integrity and decorum of the nudes in *Ego Geometria Sum*, rooted in classical humanist ideas about the ideal human form, would henceforward be rejected by Chadwick in favour of a body that possessed every quality despised and even proscribed in Judaeo-Christian thought: productive, cyclical, porous, burgeoning, ripening, subject to time, wet, leaky. With the making of *Of Mutability,* she was able to close down any yearning for an approved, conventional virtuous habitus, and open her imagination onto a vista of effluvia and detritus, of earthly slime and piss, generativity and decay, a terrain she would explore with irrepressible exuberance in the years to come, as the conundrums about female subjectivity and its relation to nature hung in her mind. In 1988 she mused in her notebook,

> *I am confused as to what ...precisely is natural anymore.*
> *Natural is really a 'moral' concept.*
> *there can never be 'Nature'*
> *only questions of what is relatively natural*[73]

Soon after the film *Imaginary Women* was made, Helen invited me round to Beck Road to see her work in progress on *The Oval Court*. Hackney was then London's wild side, as Iain Sinclair has lovingly chronicled. It was a grey, narrow street trapped between choked thoroughfares. Its Victorian terraced cottages had been slated for demolition, when a group of twenty-four artists decided to move in. The musician Genesis P-Orridge was already there, and later, others joined: the artists Trevor Shearer, Alison Turnbull, Mikey Cuddihy, the gallerist Maureen Paley, the poet and artist Pete Smith - and Helen. The group made a tenacious case for saving the houses and letting this small artists' community stay.[74] Helen curated the dossier. Her usual immaculate attention to detail and presentation helped the cause and two years later the Inner London Education Authority (ILEA) gave the squatters rights to become tenants. A little-known work of Chadwick's called *Three Houses: A Modern Moral Subject* (1987) addresses the issue of housing: she projected slides of the street, with her possessions tumbled out over the pavement out of her windows and front door, as if she were being evicted. '[T]his house... is the heartland of my life' she wrote in the catalogue, '... many of my neighbours are artists...[we] form a creative nucleus... the thought of losing our homes is all pervasive and underscores our daily lives.'[75] The artists' street is a historic achievement in itself, a collaborative work of friends.

When I visited the house that first time, the photocopier was already in operation. The Beck Road neighbours' contributions of compostable stuff was accumulating in the space at the back which had housed the outside lavatory. Bags, each carefully numbered, were also filling up with the debris of her work in the studio. Alone with her, I felt the full glamour of her personality – the flow of her talk which moved through uncannily perfect arcs and loops of sentences, which rose in artful structures and came home, landing perfectly, not unlike the acrobatics in her work in progress. She spoke declaratorily but with a tinge of endless wonder as if what she was saying was a source of endless surprise to herself. She showed me *One Flesh* (1985), the icon she had made of her friend and neighbour, the punk musician Paula Brooking, with her newborn, Caresse (fig.13).[76] At first sight the portrait is a gorgeous variation on a Byzantine mother and child, but Chadwick tunnels into the iconic religious imagery of Mary and Jesus. Her Madonna is swathed in a luxuriant scarlet robe with broderie anglaise lining, and the baby she is nursing at her breast is a girl, while she raises a pair of scissors to cut the umbilical cord.

Fleshly elements, usually denied in the religious doctrine of the virgin birth, are here made manifest – raised high to view as if in a monstrance: the cord, the placenta, the vulva of the mother, all photocopied directly from life. Paula had had her labia infibulated with several rings, and they are positioned at the apex, like a fluttering putto, with the lenticular afterbirth below it, usurping the place of the dove of the Holy Spirit. It is a profane Madonna and Child, an act of serio-comic blasphemy, and at the same time, a celebratory, opulent tribute to new life, female energy and the ordinary miracles of birth, blood and milk and lymph, sexual secretions – effluvia.

She returned to the imagery of mother and child with *Lofos Nymphon* (1987), a complex five-screen installation that pays homage to her Athens-born mother, photographing them together naked in five different embraces. They are framed in egg-shaped ovals against a backdrop of the acropolis – the 'Hill of the Nymphs' as the work's title conveys. Athens, a city dedicated to a supremely powerful and unpartnered goddess, inspired fierce identification in Chadwick.[77] *Lofos Nymphon* celebrates the tender intimacy between mother and daughter, casting them both as women on their own, born of a Parthenos (even if not exactly nymphs or virgins).

That afternoon in her studio, Chadwick also showed me many ingredients to be combined in the work she was devising: the tub of brandlings, a book about Vanitas painting filled with allegories about the transience of life,[78] images of Homo Bulla, 'man as a bubble', sometimes in the shape of a child blowing soap bubbles, and a reference to Shakespeare's dark mood in sonnet 77, 'Thy glass will show thee how thy beauties wear, / Thy dial how thy precious minutes waste...' Excitedly, she pulled out materials on baroque architecture, anatomical nudes, optics and scopic consciousness; she didn't get overexcited as she put forth all this source material but remained calm, in a kind of rapture at the vision all this was forming in her mind.

Helen Chadwick (born 1953) was then in her early thirties, neat and supple; even in her self-portraits in the nude, she has a puckish, epicene quality, what might now be termed non-binary; her hair, always cut by a Hackney barber in a precise flapper bob, framed her mischievous, pointed face with its peaked brows; she wore black and white only, in crisp shapes, and was small enough to buy her clothes at Junior Gaultier; a crucifix (visible in the photocopies) always hung round her neck on a narrow gold chain; she had bracelets on both wrists, and on her small flexible hands, several rings;

she loved a particular brooch, in the shape of a fist grasping a dagger, and wore it every day as a talisman on her lapel. Her nails were blunt, short and damaged, probably from the materials she was always experimenting with. Her smile was huge, sudden and still radiates in the photographs that survive (fig.18). Everything she did, she did with a certain panache. Her neighbour, the artist Alison Turnbull, remembers how Helen had a sampler, embroidered 'Home Sweet Home', and would lay it out slantwise on the kitchen table when offering a visitor a meal or a cup of tea.

That neat helmet of hair trailed a series of seductive associations: it was primarily the identifying feature of Louise Brooks, in her role as the heartless child-like femme fatale Lulu, the doomed protagonist of W.B. Pabst's classic silent film *Pandora's Box* (1929), based on Frank Wedekind's 'Lulu cycle' of plays. Pandora recurs as a mythic figure in women's reckonings with an ideology-laden past, and Lulu/Pandora dominates this struggle. As played by Brooks, the character obsessed Angela Carter, who wrote that

> *Louise Brooks is a name that carries with it all the resonance of a quotation, a name that instantly evokes her personal logo, that haircut, those eyebrows ... oh! the patented Brooks version of the Gioconda smile, the one that isn't so much a 'come hither' look as a look that says, to each and every gender: 'I'll come to you.' (If, that is, she likes the look of you – a big if, in fact.)[79]*

In 1987 Carter translated and adapted Franz Wedekind's plays as the single play *Lulu* for the National Theatre, but it seems the team there found her version too extreme and it never reached the stage.

With her haircut, those defiant wide-open eyes and smile, Chadwick resurrected that dangerous and irresistible spirit, with its glints of perversity.

Needless to say, I was enthralled, and when she asked me to write about her new work, I said yes without a moment's thought.

❄

The catalogue was designed by the artist, and it was – and is – a characteristically perfectionist production, its cover the deep blue of *The Oval Court*, with the digital drawing of the Bernini column on the cover, together with

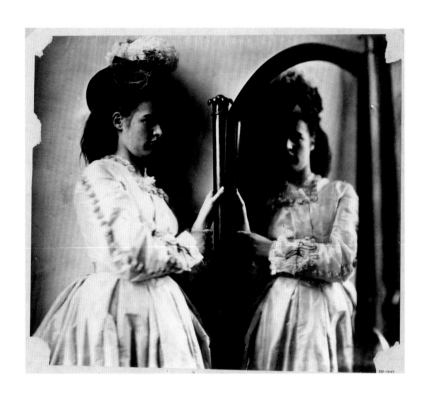

32. Lady Clementina Hawarden,
Clementina Maude, 5 Princes Gardens,
c.1863-64, albumen print from wet
collodion negative, 23.8 × 27.5 cm.
© Victoria and Albert Museum, London

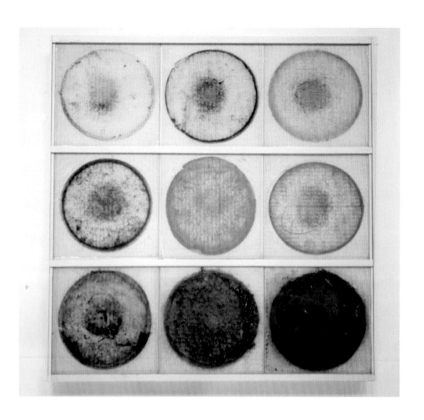

33. Judy Clark, *Housedust*, 1973.
Jane England Gallery.
Courtesy the artist

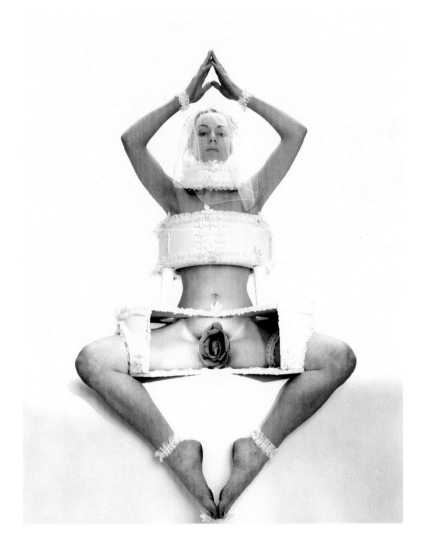

34. Penny Slinger, *Rosebud*, 1973,
original archival photo and collage.
© Penny Slinger. All Rights Reserved,
DACS/ Artimage 2022.

Can I transform others?
Does it Really matter?
I want to be happy
I can transform myself

35. Jo Spence, *Only when I got to fifty
did I realise I was Cinderella (06)*, 1984,
artist laminated exhibition panel,
32.5 × 32.5cm © Jo Spence Memorial
Archive, Ryerson Image Centre, Toronto
and The Hyman Collection, London

Ameconi, Pinx.?
Alex.? Vanhacken fecit.—

Feeling

Published According to Act of Parliament by T. Jefferys in the Strand and W. Herbert on London bridge.

36. Alexander of Haecken, *Gevoel (Feeling)*,
1739, mezzotint on paper, 35.5 × 25.3 cm,
© Art World / Alamy Stock Photo

Above:
37. Joachim Beuckelaer, *The Four Elements: Earth*, 1569, oil on canvas. National Gallery, London

Below:
38. Clara Peeters, *Still Life with fish, a candle, artichokes, crab and prawns*, 1611, oil on panel. Prado, Madrid.

39. Jan Gossaert, *The Metamorphosis of Hermaphroditus and Salmacis*, c.1517, oil on oak panel, 32.8 × 21.5 cm. Collection Museum Boijmans Van Beuningen, Rotterdam.

40-41. Vénus de Lespugue, Paleolithic
sculpture. Musée de l'Homme, Paris

a single airborne goose feather like an ectoplasmic smudge on a glass plate. Later, after Helen had died, Mark Haworth-Booth wrote a poem called 'A Hand of Feathers' in her memory, evoking the flight and fragility of this emblem of life and alluding to Darwin's notes on the bowerbird:

> which builds a vaulted passage-way
> beside its nest, a kind of gallery
> Of landshells and seashells, bones and feathers
> [...]
> This early form of installation art
> Charles Darwin called a space for 'playing in'.[80]

Feathers, like bubbles, also conveyed something Chadwick practised in the course of her quest as an artist: lightness, the quality Calvino praised as *leggerezza*, and which she found in the mode of Rococo.

Being a woman artist

My essay had to be written long before *Of Mutability* was installed, when I had only seen single photocopies, so it relies on the artist's lucidity and eloquence as well as source materials she introduced me to. In many ways I ventriloquised her or at the very least took my cue from what she disclosed.

Reading it again now, I feel some of the allusions are strained: it was her idea to illustrate the Atomium in Brussels in relation to her use of golden spheres, but without more discussion of her passion for science, it looks incongruous. However, because my piece incorporates so much of what Helen told me about her inspiration and aims, it illuminates the work from her point of view at the time. I have reservations now about accepting artists as the dominant explicators of their works, partly because their words can take precedence over the art itself, and partly because the experience of a work on that scale will have qualities that the artist cannot forecast or altogether know. Chadwick's notebooks are dazzling in their range of questions and allusions, and you can see the darting of her mind as she chases the words to convey the work she is envisioning. In her shapely, characterful handwriting, she reveals the intensity of her studies and her fierce, attentive reading of history, science and art theory (fig.19). Stephen Walker's 2013 study grapples brilliantly with her cryptic – indeed oracular – jottings and his discussions of them are very rich. But I am not attempting to read Chadwick's mind in this same way, through her ideas. At least not only. I would like to understand the work in terms she has not entirely set.

Marcel Duchamp performed a characteristically subtle double manoeuvre with his readymades: the semiological *jeu d'esprit* demonstrated that any object – a bottle rack, a urinal – can be a work of art if it is designated as such, and at the same time he ironised this act of aesthetic enchantment by choosing such mundane objects to transform. Along both axes, however, the artist was in charge and the viewer needed to be admitted into the charmed realm he or she had named. Chadwick is not a conceptual artist in this lineage, but in her statements to me about the whole enterprise she was embarked on, she showed herself to be deeply engaged with speaking as an independent subject and controlling the meaning of her own subjectivity; indeed the issue that dominates the essay I wrote under her guidance, keeps circling round the autonomy and self-expression of the female body, how the figures of lovers in the pool are in charge of the amatory encounters and twinings that take place

in it, and the mourning of the weepers around it. In her notes, I found a leaflet from a show of the artist Hermione Wiltshire, in which the quest for female presence makes a crucial move from somatic knowledge to inward fantasy: 'my work is no longer me my body, rather a state of fantastic projection. I am trying to picture a psychological state, one of indefinable possibilities.'[81] This discourse recognisably arises from feminist aims of the time, now so profoundly accepted that the ambition can feel a little dated. Of course, the fact that this struggle for women to be heard in their own right as artists has been superseded by other issues should inspire relief if not joy.

Chadwick's fierce rejection of traditional female contingency inspired me to begin the essay with an image of Eve alone in Eden, no Adam. The artist had photographed herself, naked, in the present day, in a paradise, and these images reverberated with the history of Eve, whom God decrees to be a helpmeet (Gen. 3:16). I re-envisioned Chadwick's multiple naked figures as solitary anti-Eves, embarked on gratifying the lineaments of their desire.

In Chadwick's vision of paradise, the cause of the inevitable Fall is not sin or shame, but time and the natural cycle. Chadwick was Greek Orthodox on her mother's side, and she shows knowledge of Christian doctrine and a love of its aesthetics (as revealed by *One Flesh* and the gold crucifix she wore). *The Oval Court* can be read as a furious rebuttal of sexual guilt in general and female sexual sinfulness in particular. Attitudes to sexual liberation have since profoundly changed; from the late 1960s through the 1980s, women's self-fulfilment was seen as intrinsically interwoven with freedom from expectations of marriage and motherhood, from ideals of purity and monogamy. 'Utopian Erotics' is a phrase used of artists such as Niki de Saint Phalle and Carolee Schneeman, intrepid questors for sexual autonomy for women. Looking back on *Meat Joy*, Schneeman's 1964 happening which involved lots of naked bodies rolling around orgiastically in a mess of mackerel, chickens, and sausages (none in a fresh condition), the artist commented, 'The culture was starved in terms of sensuousness because sensuality was always confused with pornography. The old patriarchal morality ... had no threshold for the pleasures of physical contact that were not explicitly about sex but related to something more ancient – the worship of nature, the worship of the body, a pleasure in sensuousness.'[82] These aims come close to Chadwick's, especially in their focus on a range of pleasures, not exclusively sexual.

Self-knowledge was a powerful motive for artist of this generation. During a performance, called *Mirror Check* (1970), Joan Jonas stood naked and examined her body slowly all over with a compact mirror. She was enacting embodied self-discovery and demonstrating her emergence from women's long servitude as objects of male desire, chattels, dependents and subordinates. Chadwick's bodily celebration also recognisably belongs with Angela Carter's libertine eroticism (including swerves into sado-masochism) but is not confined by it. *Of Mutability* turns the doctrine of the Fall upside down and stages a pagan, orgiastic, un-mastered Eve, a free spirit of a woman in a body that's guiltlessly gorging on pleasure.

I was one of many feminists at the time who tackled the legacy of the doctrine of original sin – that women were occasions of sin as well as subordinates. Helen asked me to write for the catalogue partly because she had read the book I wrote about the Virgin Mary's effect on the role of women down the centuries. Among the many associations of blueness which we explored together, the expensive ground lapis lazuli used to paint the Virgin's mantle was a reason; the scarlet cloak on the Madonna in *One Flesh* remembers this, in transgressive inversion.

The legacy of sexual liberation has hardly proved uncomplicated for girls and women, but examining these issues would carry us too far from Chadwick and her work. Developments in women's quest for identity, how-ever, have in particular altered the significance of a key motif in *The Oval Court*: the mirror, from its symbolic status as an attribute of Venus, sirens, and Luxuria (lust), to its resonance as a tool of self-knowledge (self-help manuals in the 1960s encouraged women to examine themselves fearlessly; third wave feminism advocated self-re-creation and performativity).

Of Mutability's grand conception placed it, consciously, in a Vanitas tradition. The word – and the trope – enclose a slippage between the tran-sitoriness of all things and the deadly sin of vanity, between sin and death, which entered the world at the Fall. This slippage is embedded in the opening lament of Ecclesiastes, 'Vanity of vanities, all is vanity.' (Eccles. 1:2). In Judaeo-Christianity, mortality entails that all earthly glories fade, as must individual beauty from creation. The genre of Still Life, which is translated in French as *Nature morte*, lies very close to the Vanitas tradition, and also castigates sinful-ness – Greed, indulgence and love of luxury. *The Paston Treasure*, a mysteri-ous, anonymous seventeenth-century painting, glories in the curiosities and

delicacies spread on a groaning table, and yet at the same time, seems eerily to lament the emptiness of these pleasures, these riches. Interestingly many women artists have distinguished themselves in this tradition, and the attraction Chadwick expresses in her depiction of natural abundance resonates with Clara Peeters' studies of freshly killed fish, as in *Still life with fish, candle, artichokes, crab and prawns* (1588, fig.38) – the snuffed candle indicating the moral dimension that life is short and its delights fleeting. The still lives that appear in Chadwick's pool have been displaced, surrealistically, from the kitchen, the larder or the table, and float in indeterminate space; the creatures and vegetables acquire an aesthetic and individual presence on their own terms, as in Juan Sánchez Cotán's eerie still lives such as *Quince, Cabbage, Melon and Cucumber* (1602) in which the produce he is representing is strung up and laid out against a black background.

In contrast to this Dutch and Spanish melancholy, classical Pythagorean thought holds that 'nothing dies but always goes on living', as the Roman poet Ovid writes towards the end of his *Metamorphoses*. Lucretius' *De Rerum Natura* is among Chadwick's books, and its concept of fluid and cyclical returns is echoed in Spenser's *Faerie Queene*. Mutability is an aspect of mortality but not its end: from putrefaction new life emerges. The process is alchemical, and in the life cycle of every phenomenon, dross is transmuted into gold and inert matter into living organisms. (A letter from a perceptive fan, praising the whole installation that makes up *Of Mutability* commented that if *Carcass* had only been left alone, it would have eventually begun to sprout and give birth to new life.)[83] Chadwick looked in the mirror and exulted in what she found there; her mood was not one of censure even if she depicted herself weeping at transience.

Altering the apocalyptic Biblical indictment of vanity led Chadwick to reassess narcissism, and to modify Freud's pejorative notion of the 'complex'. In her notebook, she wrote, 'Desire + Love Sexuality/ Narcissism *Jouissance*'.[84] She was moving towards French reformulations of self-love, as in Julia Kristeva's 'narcissian' reformulation:

> *Instead of self-inculpation, instead of feeling unhappy before your image ... go ahead, love yourself. Henceforth introspection becomes a right, thus permitting the constitution of an individual psychic space... Introspection, which is always to some extent amorous, is possible*

because you love The One and The One loves you, lacking which condition you have no right to this reparatory and consolidating self-contemplation. It is by virtue of love that this space is strengthened, and by virtue of such a psychic space that you are able to brave disappointments, hard blows.[85]

I missed the force of this passage at the time, perhaps because its blazingly prophetic character was not then as striking as it is now. But it really illuminates Chadwick's enterprise of embodied self-affirmation, in a colossal declaration of resistance to millennia of wounding belittlement and condemnation. *Of Mutability* is an act of narcissian love: art, like crying, Chadwick wrote at the time 'is an act of self-repair, shed the natural tears that free us, make us strong.'[86] She was turning self-love into self-examination, and trying out different selves through performance and costume. Forerunners among photographers had also explored this: Julia Margaret Cameron dressed up her subjects as characters from history and poetry, while Clementina Hawarden posed her daughters in various guises and fancy dress, often contemplating themselves in mirrors as if encountering themselves as new strangers (fig.32). On two pages about self-portraiture as a way of discovering, not revealing, the self, Chadwick notes, 'the maxim, "the camera cannot lie": yet within this apparent objectivity are whole possibilities for construction – it doesn't have to tell the truth either or it could build truths that don't exist.'[87]

At the time Chadwick was making *Of Mutability*, she created a series of *Vanitas* images (1985, fig.14), for which she posed in the nude, contemplating herself in angled mirrors, with sensuous ornaments on her nakedness such as feathers and jewels. In *Ruin* (1986), another image from this series, the artist covers her face with her left arm, while her right hand rests on a skull. These photographic works are highly staged, ironic, performative rejoinders to the dominant topos of the vanitas tradition which shows a nubile body often haunted by death in the form of a rapacious skeleton.[88]

Whereas at the time, Chadwick was attacked for retrograde ways of looking and for betraying feminist principles about female representation, the narcissian strand in her oeuvre has proved crucially attuned to later developments of auto-fiction, both in visual arts and in writing, with its pursuit of subjectivity through self-fashioning and self-display. The tradition goes back at least to the early nineteenth century, when Emma Hamilton was

celebrated for posing as characters from myth and history – her 'attitudes.' Chadwick, as we have seen, was also supremely aware of Kahlo's performances in the mirror and on canvas. Following in a strongly female lineage of artists satirically disrupting narcissian stereotypes, Chadwick wasn't alone: her younger contemporary Maud Sulter (1960-2008) created an inspired series of photographic self-portraits. Sulter also appropriated female artistic tropes and portraiture to unsettle their traditional messages; in this case, the artist deranged habitual attitudes to blackness, beauty and power relations. When Chadwick saw Cindy Sherman's work in 1987 in New York, she was particularly struck by the way the American photographer staged herself at the centre of scenes of violation and disfigurement.[89]

Reversing the monstrous

When nature has stopped being treated as the enemy of man, when the battle of the sexes has become an unknown, when the so-called feminine traits that men share in full measure - feelings, moods, intuition - have been fully exploited, when the significance of women's contribution to the preservation and development of human society has been recognised, when comfort is no longer mistaken for culture, when beauty has become a need again - then at last, poetry and art will automatically come into their own once more...
- Meret Oppenheim, 1975[90]

Chadwick's sensitivity to new technical inventions in the sphere of optics and reproduction underlies a significant element in her posthumous influence. She intuited how the new means of mechanical reproduction were placing tools for forging subjectivity in the hands of subjects who had not previously enjoyed access. She did not live to see the rise of the selfie, but when she - and Susan Hiller - made their photobooth portraits, it is as though they were seeing the future.

Although Chadwick was engaged very closely with optical media, she was searching for ways of making them serve other senses, especially touch. Those spheres in the pool, made to the relative proportions of her fingers and thumb, idealised haptic knowledge. All five senses, a common cycle of allegorical figures, were necessary to her quest of pressing optical media into refashioning - inverting - mortal tropes. As Mary Horlock has perceptively remarked, 'With Chadwick there was always strong intent to seduce.'[91] Touch is often depicted, in traditional iconography, with a feather in the hand, sensuously brushing skin or testing the point of the quill on a finger, as if it were Cupid's arrow (fig.36). The blindness of the god of love usually means that love strikes at random, but it also concedes that other senses - taste, smell, touch - play a crucial part in erotic passion. 'It's hard to keep all five senses going at the same time,' the artist wrote, 'but I do try to undermine the primacy of the eye. Or use the eye to elevate and privilege some of the other senses.'[92] The figures in the pool are all making intimate contact with their playmates, and in every case the imagery evokes sensations, as Chadwick set out to express: 'I want to catch the physical sensations passing across

the body – sensations of gasping, yearning, breathing, fullness. The bodies are bearing their sexuality like a kind of Aeolian harp, through which the sensations are drifting and playing.'[93] Contemporary pornography ratchets up visuals in forensic close-up precisely because it cannot find a means to expressing the feeling of arousal conducted by the other faculties besides sight. Aristotle did not forget the importance of these senses, and wrote in his treatise on the soul that 'taste is more discriminating with us because it is a form of touch and this sense in man is highly discriminating; in the other senses he is behind many kinds of animal, but in touch he is much more discriminating ... This is why he is of all living creatures the most intelligent.'[94] Chadwick echoed this when she said she wanted to communicate through her images 'the discharge of energy that occurs in touch.'[95]

In a wonderful comic and dissident tale, called 'L'Amour est aveugle' (Love Is Blind) Boris Vian, the French Surrealist, jazz musician, ironic occultist and pataphysician, imagines a thick fog gradually descending in layers over Paris, first obscuring people's feet, then everything else. This fog is warm, sweet-smelling and resonant, and as it wraps each thing and everyone, it has a powerful effect: it's an aphrodisiac blanket. Unable to see, only to feel one another, Parisians embark on a wild, exhilarating joyous orgy. After a few days of 'this simple and sweet life ... in the image of the god Pan', the fog begins to lift, and a great council meeting takes place to meet the threat. But 'when the fog melted away, as was indicated by special detectors, life could continue happy, since everyone had put out their eyes.'[96]

It is a *jeu d'esprit* and Vian has a streak of dark devilry – he is most notorious for his crime fiction, *J'irai cracher sur vos tombes* (*I Spit on Your Grave*, 1946) a tale of revenge for a Southern lynching – but the lyrical eroticism of *The Oval Court* should not obscure Chadwick's own edginess. After all, her favourite film was *Videodrome* (1983), and the moments of strain in extremis that she dramatises in the pool complicate the sumptuous display and the rococo aesthetics.

Talking in this way about the struggle to expand visual lexicon to convey embodied experience, Helen inspired me to write a proposal for a film based on 'The Tale of Cupid & Psyche', focussing on the nocturnal visits of the god to his lover, who has been forbidden to see him. Goaded by her jealous sisters, she breaks the prohibition, lights a lamp and a drop of oil falls on the sleeping god, who wakes, whereupon everything around her disappears

– the enchanted palace, the invisible attendants, the magic music and feasts. Helen was to create the visuals that would communicate Cupid and Psyche's exclusively haptic encounters; she would extend her search for triggers and correlatives for sensations of pleasure. It was presented as one film in a set of six, the sixth sense (instinct, telepathy) added to the conventional five. Unfortunately, the proposal for the series was rejected.[97]

<div align="center">❀</div>

The works of Chadwick which were to follow *Of Mutability* keep up her quest for a novel aesthetic grounded in exuberant sensory delight and yet contained by canonical classical form. *The Oval Court* was a first step into that laboratory where she experimented with matter of all kinds, with the raw meat and genitalia of the works in the *Meat Abstracts* and *Meat Lamps* series (1989-1990), the shocking oxymoron of *Loop My Loop* (1991, fig.15), blonde tresses wound with pigs' entrails, the lambs' tongues and fur tippets in *Glossolalia* (1993). The numbered series *Wreaths to Pleasure* (1992-93) inspired the artist to make even more daring juxtapositions of colour and texture as she combined antithetical organic stuff – slimy, spikey, sticky, silky and furry. Sometimes she would play with a visual pun – a penis and scrotum made of roses in a pool of Germolene (*Number 10*, 1993); an oyster surrounded by buttercups, entitled *Eat Me* (1991), suggesting cunnilingus; a knobbly gherkin cuffed in mink for a marriage gift (*I Thee Wed*, 1993). She produced frissons in viewers with her amalgams of utterly antithetical substances – teal blue Ariel washing liquid and pinky-orange sweet peas (*Number 5*, 1993, fig.16); daisies, Swarfega and tomato sauce (*Number 7*, 1992-93); gerberas, fur, and lard (*Number 8*, 1992); orchids, lime marma- lade and Windolene (*Number 11*, 1992).[98]

These daring challenges to conventions of tastefulness brilliantly threw different switches in the viewer's sensorium, making usually revolting things delicate, and unappetising (even foul) leavings inviting. Scatology, as in Georges Bataille's riposte to Surrealism, and its angelic opposite, cleanli- ness, offered Chadwick welcome terrain. As a child, she was often ill, and in her conversation with Mark Haworth-Booth, she recalls childhood experi- ences of being wrapped in an eiderdown, this sensation 'of being in a warm tub of excrement', she said, 'but also the clear crispness of new sheets and

laundered pyjamas on Sundays in the early evening – an unrivalled feeling even now.'[99] In the interview with Judith Collins, she related how she 'foraged around in woods [behind her family's house in Croydon] and collected animal droppings and dribblings and kept them in little boxes ... I would store little follies, such as fingernail parings ... They were my childhood treasures.'[100] In 1991-92, she created the notorious installation *Piss Flowers*, from the holes made in deep snow by her partner David Notarius and herself. The magnificent ambiguous burping *Cacao* (1994), a fountain bubbling with chocolate would follow.[101] Though the public mostly saw *Cacao*'s phallic references, to Chadwick herself it was explicitly androgynous, like an enormous liquidinous flower.'[102]

Charles Baudelaire declared disgust his life's aim: 'When I have inspired universal horror and disgust,' he wrote in *Fusées* (1867), 'I shall have conquered solitude'.[103] Chadwick was mining this seam she found expressed in Bataille's erotica and scatology, but, while Chadwick's flouting of the usual criteria of art reflects the French thinker's exaltation of the *informe* and the larval, she emphatically did not want to provoke disgust, or even (disgust's sometime companion) pity. Whereas Bataille delighted – even revelled – in the acceptance of foulness, like those saints who licked the putrid sores of the sick, Chadwick was intent on transfiguring the foul into the fair and fragrant.[104] Chadwick was interested in the psychoanalytic philosophy of Julia Kristeva whose thoughts on abjection found full expression in *Powers of Horror* (1980), in which she discusses the harrowing picture of Holbein's *The Body of the Dead Christ in the Tomb*. Both Bataille and Kristeva locate the sacred in degradation; both are magnetised by the category of the despised as such, without any attempt to reconfigure its defining qualities. Chadwick was also attracted to the loathly and unspeakable, but she twisted this tradition because she was intent on transforming objects qua images; she was in effect sublimating them till they were no longer recognisable as low and putrid.

In the 1980s, *Purity and Danger* (1966), by the anthropologist Mary Douglas, was another seminal influence, and haunts Chadwick's quest for a new beauty grounded in matter, no matter how base. You could say, taking a cue from Douglas's axiom, 'Dirt is matter out of place', that Chadwick was on a mission to transvalue dirt. She reassigned the places of dirt to make them matter in a different, acceptable way, to transvalue despised forms of

stuff, to bring the creaturely into the ambit of the aesthetic and hence, taste. There was no Christian love of humiliation in these artistic acts; she was rebellious against all standard pieties.

Chadwick's concern with the rejected remained consistent throughout her career: before tackling a different category of reject with *Carcass*, she had made sculptures in the 1970s with used tampons. As half-Greek, she was disturbed by rising hostility to strangers and foreigners – a different form of rejection altogether. Themes of belonging had attracted her, as in *Ego Geometria Sum*, and bodies stigmatised for any reason preoccupied her till the last years of her life, when she made *Xenophilia* (1995), another large installation dedicated to heroic lives of *xenoi*, 'strangers' in Greek, but also guests/hosts. She was reading Kristeva's *Strangers to Ourselves* (1991): the philosopher had moved across from thinking about the embodied experience of being a woman and the abhorrence provoked by bodily functions, such as reproduction and maternity, to thinking about relations between incomer and outsider.[105] Chadwick intimated the rise of exclusion and hostility in the present world with uncanny foresight. Her early punk activities and her general irreverence have sometimes cast her as a postmodernist, but this is a limited approach. She did not borrow from the past in a mode of pastiche to ironise her subjects; rather, Chadwick was admirably grappling with deep issues and, in spite of that impish smile, she was surprisingly earnest.

In the last years of her life the artist won permission to work with discarded embryos, manipulating them through a pipette.[106] She then framed the photographs in jewelled settings, hanging them in an arc, like pearls on a necklace (*Nebula*, 1996, fig.17), a gem in a brooch (*Monstrance*, 1996), and the centrepiece of a ring (*Opal*, 1996). Works she left unfinished performed a similar act of enchanted, artistic transfiguration on anomalous bodies from the Hunterian Museum: here she gave her attention to individuals whom scientists had collected as objects of study and designated curiosities and monsters. Chadwick framed these images in 'cameos' made according to the highest aesthetic principles, such as Hogarth's 'Line of Beauty'. When she died in 1996, she had only completed the Cyclops child and the chimpanzee; she was planning to enshrine – to restore to dignity – specimens of a stillborn 'Pigmy' baby, a hermaphrodite and a triplet.[107] She told me, in passionate tones, that she found the Cyclops baby 'truly beautiful'. What had been clas-

sified as monstrous and aberrant could not be, in her eyes, confined to that category. She did not see herself as acting to reconcile or to heal, but as someone who could escape the narrow paradigm of prescribed forms and bring about a revolution in perception.

Towards non-gendered sexuality

Another theme central to this search for a contemporary aesthetic does not surface perceptibly in *Of Mutability* but materialises clearly in the light of later works. The work for *Of Mutability* unsettled normative binary oppositions between nature and culture, male and female, time and stasis, the real and the ideal, purity and decay and beauty and ugliness. During her conversations with Haworth-Booth, the artist expresses herself forcefully on her search for a *coincidentia oppositorum*: 'These counterpoised values that should be oppositional I think combine to create a synthesis that opens up a different way of evaluating what's before you, when the old rules don't apply.'[108] Her questions 'became organised around continua ... she approached nature as part of a multistable system.'[109] Stephen Walker astutely comments,

> *Her denial of nature was less along [these] lines of momentary and localised reversals of the accepted hierarchical relationship between nature and artifice (reversals that leave the main 'whole' undisturbed) and more concerned with exploring the alternative relationships derived across a continuum of void, the energy of illusion, the combination of concrete reality and imagination.*[110]

Chadwick found in nature a symbolic figure to embody her ambition: the hermaphrodite. In spite of the orgiastic scene in the pool and the allegory of *female* desire, a yearning for hermaphroditic completeness – for a continuum between the biological sexes – can be sensed beneath the tumult. The weeping faces are not gendered; nor are the animals. There are, as I pointed out before, no evident males, human or otherwise. In their solitude, the females are sufficient unto themselves. For Chadwick, so preoccupied with fleshhood, difference was experienced as a cutting off of possibility, a wound.[111]

Ovid, telling the story of Hermaphroditus, evokes the intensity of Salmacis' passion for the young man; she's a naiad, and very siren-like in the poet's description, as she beckons him into her spring waters and in the fury of her love, dissolves him into her being (fig.39). Ted Hughes's version came out in 1994, so Chadwick could not have known it, but she uncannily seems to share the poem's passionate aquatic fantasy:

And suddenly he was swimming, a head bobbing,
... shoulders liquefied,
Legs as if at home in a frog's grotto,
Within a heave of lustre limpid as air
Like a man of ivory glossed in glass,
Or a lily in a bulb of crystal.[112]

The artist was deeply affected by Michel Foucault's distressing edition of Herculine Barbin's Memoirs. Barbin was brought up as a girl from birth but, on account of their hermaphrodite organs, was forced to live as a male; they committed suicide at the age of thirty. 'The happy limbo of a sheltered non-identity,' wrote Chadwick, 'the tender nameless pleasures she writes of, end in tragedy. Why do we feel compelled to read gender and automatically wish to sex the body before us as we can orientate our desire and thus gain pleasure or reject what we see?'[113]

The artist was again showing prescience. She sensed the narrowness of gender oppositions when she was making *The Oval Court*, and this intimation grew more defined in her later explorations. She admired the work of the artist-scientist Jack Butler and she asked permission to reprint, in the US catalogue of *Piss Flowers*, parts of an article he wrote called 'Before Sexual Difference'. It opens, 'Early in the ninth week of life in the womb, the human embryo develops a surprisingly large proto-clitoris/proto-penis genital structure technically designated as the indifferent, neuter or common genitalia.'[114] This biological finding, which corresponds to an eighteenth-century concept of genital mirroring (the male organs an extruded version of the female)[115] stimulated Chadwick's curiosity about the reproductive ways of other species. William G. Eberhard's *Sexual Selection and Animal Genitalia* (1986) was reviewed in the *London Review of Books* at the time she was making *Of Mutability*; among the artist's papers I found the page in question, with a drawing of 'Seahorses doing it: the female, on the left, has put her intromittent organ into the male.'[116] The male of this species also has a pouch in which the young are nourished. Chadwick shared with many contemporaries utopian dreams of alternatives – an exhibition at the New Museum in New York called 'The Other Man: Alternative Representations of Masculinity' (May–July 1987) also caught her attention at this time. When Haworth-Booth asked her if she could remember her first dream, she an-

swered that she had recurring dreams of flying: 'I was able to, twisting my arms behind my back to get lift off.' She then went on, 'I was often changing sex in dreams. I've a feeling that my alter ego was male, when it was determined what I was at all, I think it was male.'[117] In the years following *Of Mutability*, she would work more and more with blooms and flowers, which are, as she trenchantly put it, 'the bisexual reproductive organs of plants',[118] and frequently hermaphroditic.

Of Mutability can therefore be seen as a laboratory experiment, with bodies of all kinds under observation in conditions of primordial bliss and reciprocity. Chadwick often displayed a soothsaying sense of current issues, as with *Train of Thought* and her last works with discarded embryos and reproductive technologies (then in their early, contentious years; they have now made parenting possible for many, including same-sex couples). Her photographic work with the male body from the 1990s incorporates close ups of genitals and other parts, drawing attention to the commonality of protuberances, orifices, hairiness. She is gleeful (naughty) as she makes gorgeous floral emblems, close in spirit to a municipal flower bed, of a penis or a navel (*Billy Bud*, 1994). The poem she wrote for *Piss Flowers* – the only poem she had ever written, she said – 'came out of restless hyped-up sleep'. It's 'a metaphysical conceit', a dazzling piece of erotic wit,[119] but it draws attention to the way Notarius and Chadwick were exchanged in the act of making the snow sculptures:

> *organs doubled*
> *... vaginal towers*
> *with male skirt,*
> *gender bending water sport ...*

The poem ends:

> *Suck my penis envy farce*
> *Like old Vénus de Lespugue.*[120]

This prodigious Venus, a figurine of a Magna Mater from the Gravettian culture of the upper Palaeolithic, 26-24,000 years ago, burgeons with woman's secondary sexual characteristics, but overall, the form is also

ambiguously erect and bulbous, even phallic (fig.40–41). In twenty-first century terms, you could say the self-portraits in Chadwick's pool of tears are struggling towards freedom from the need for an Other, and intimate the possibility of a non-binary identity.

London, 1996

On the morning of 15 March 1996, Helen Chadwick was once again visiting the Print Room at the V&A to look at the work of Anna Maria Garthwaite, the Spitalfields weaver and designer. In these final moments of her life, endless demands were being made on her, but she was still focussed on making her art, and that day she was looking for different elements of decorative and elegant design to incorporate into the series of Cameos she was creating. Her head filled with ideas, she left the Museum for the Architectural Association in Bedford Square, where she was due to discuss a collaboration and attend a lecture. On arrival, she was not feeling well and asked for a glass of water. When someone brought her one, it was already too late.[121]

Helen's dazzling articulacy maybe cloaked something; or so it seems to me now at this distance. She was so quick and lively and brilliant and appeared to be elucidating everything so thoroughly, with such a strong relish for life and such endless pleasure in the discoveries she was making; in one amazing work after another, she seemed to be offering her inner worlds for view. But, with hindsight, a quarter of a century already since her sudden tragic death, I find myself wondering what was happening to her deep down, especially when her interest in diagnostics and the body's limits was growing so intense. The emotions she communicates, enfleshed in the aesthetic adventures she undertook in every work she made, are sublimated: what was going on inside her? In that sense, she spoke very little about herself, and so much else was fascinating about her that, when she was alive, it felt like prying to ask her to say more about her motives. There are closed materials in the archive: maybe some future writer will read what she was feeling, deep down and what she was going through.

For the memorial service at St Martin's in the Fields, the artist Cathy de Monchaux and other friends created a river of orange and yellow gerberas the length of the nave.[122] I was asked to speak and it was hard; we had all lost a dear friend, a magnificent spirit and an extraordinary, constantly inventive artist who had still so much she wanted to create. It was an immense gathering, a sign that her brilliance, originality, wit and charm had inspired love and admiration in so many. She was a forerunner, who embarked on many lines of artistic inquiry that were startling when she did, but have become familiar

since then, and necessary to understanding identity, ecology, ethics. It seemed, soon after this shock of her early death, that her prophetic vision had always included a disquieting awareness of life's fragility and her own mortality. For the retrospective at the Barbican Art Gallery in 2004, five poets were asked to look at Chadwick's work for a series of postcards. Kathleen Jamie began:

> *Though delighting in fishes and birds'*
> *unfurled wings, are we ready to waltz*
> *with the dead in our arms...?*[123]

With hindsight, *Of Mutability* showed the artist more than usually aware of mortality; it is an oracular memorial to fugitive delight, uncannily filled with an apprehension of what was to come.

1 Helen Chadwick, Notebook 19/E/7. Box 24, Helen Chadwick Collection, Henry Moore Institute, Leeds (hereafter HMI); see https://www.henry-moore.org/archives-and-library/archive-of-sculptors-papers/turning-the-pages---helen-chadwicks-notebooks Unless otherwise noted, the boxes refer to the Helen Chadwick Collection. See also Stephen Walker, *Helen Chadwick: Constructing Identities between Art and Architecture*, London: I.B. Tauris, 2013. A diagram of the arrangement of the figures in the Pool has been very helpfully reconstructed in Imogen Racz, 'Helen Chadwick's *Of Mutability*: Process and Postmodernism', *Journal of Visual Art Practice*, vol.16, no.1, 2016, p.10, available at https://dx.doi.org/10.1080/14702029.2016.1206442 (last accessed 14 July 2021).

2 H. Chadwick, Notebook 19.7. Box 1, HMI.

3 *Ibid.*

4 *Ibid.*

5 *Ibid.*

6 *Ibid.* Chadwick also read closely, with much underlining, a dense essay by Thomas McEvilley about nakedness in Eden and in art across cultures. See Thomas McEvilley, 'Who told thee that thou was't naked: The Immaculate Commission in the Emperor's New Clothes', *Artforum International*, vol.25, no.6, February 1987, pp.102-108.

7 According to legend, the sculptor was paying tribute to the Pope's favourite niece who had suffered recently from a protracted labour. See Philipp Fehl, 'The "Stemme" on Bernini's Baldacchino in St Peter's: A Forgotten Compliment', *The Burlington Magazine*, vol.880, no.118, July 1976, pp.484-491.

8 H. Chadwick, 'Four Walls' (press release), Group Exhibition, Camerawork, London, UK, 1985. Box 1, HMI.

9 H. Chadwick, 'Piss Posy', reprinted in *Piss Flowers: Helen Chadwick* (exh. cat.), Nottingham: Angel Row Gallery, 1993; *Stilled Lives* (exh. cat.), Edinburgh: Portfolio Gallery, 1997, unpaginated; *In Side Up: Helen Chadwick*, Shelagh Keeley, Banff, Alberta: Walter Phillips Gallery, 1991, p.3.

10 Note in the Helen Chadwick papers at the V&A Collections.

11 Naomi Miller, *Heavenly Caves: Reflections on the Garden Grotto*, Boston: George Allen and Unwin, 1982; S. Walker, 'The Grotto and Architectural Conceit', in *Helen Chadwick: Constructing Identities Between Art and Architecture*, *op. cit.*, p.100.

12 H. Chadwick, Notebook 19.7. Box 1, HMI.

13 H. Chadwick, Interview with Mark Haworth-Booth, conducted 5 August 1994 and 12 August 1994, Tape 6/8, 6'20, Shelf mark C459/53, in the Oral History of British Photography section of the National Sound Archive at the British Library (hereafter BL). A shortened version is included in *Stilled Lives*, *op. cit.*, unpaginated.

14 H. Chadwick, Notebook 19/7. Box 1, HMI.

15 Personal recollection of Alison Turnbull, private communication with the author, 8 October 2021.

16 H. Chadwick, Tape 4/8, 16', BL.

17 H. Chadwick, Tape 4/8, 19', BL.

18 H. Chadwick, Letter to Bill McAllister, 28 June 1986. Box 100, HMI.

19 'La Cour ovale' (press release). Box 100, HMI. The exhibition travelled to Ikon gallery till 23 August 1986, then to Spacex Gallery, Exeter, Third Eye, Glasgow, Harris Museum and Art Gallery, Preston, till 1987.

20 See H. Chadwick, Interview with M. Haworth-Booth, *op. cit.*

21 H. Chadwick in Iain Gale, 'Helen Chadwick talking to Iain Gale', *Modern Painters*, vol.7, no.3, October 1994, pp.106-7.

22 *Philoxenia*, a major installation piece, was lost in the fire. It was shown in Glarus, Turin, 22 October-24 November 1995. As far as I can tell, it now exists only in a single photograph and some notes, giving the names of the ten elements, each named after a different woman and stranger (Philoxenia means love of the foreign). Esther from the Bible is the most familiar of the ten women, but Tassoula, not as readily recognisable, may refer to a Greek musician. The other names are Akiko, Orshi, Uzma, Huei, Labrini, Niyatee, Nawal and Sutapa. The media included oil and fur.

23 Michael Newman wrote the programme notes for the Tate leaflet, 1987. Box 9, HMI.

24 See Box 9, HMI.

25 M. Haworth-Booth, 'Collecting and Writing' (lecture notes), kindly provided by the author. In an email on 27 October 2021, Mark added, 'I gave Elizabeth [Esteve-Coll] a copy of your ICA catalogue soon after the show opened in 1986 and she kept it on her bedside table. So she was very well informed about the work when I proposed its acquisition after the tour ended. I had to agree to my purchase grant for two years being waived to make up the funds to buy it. All this would be on the Registered Papers for the purchase - made over two years for tax reasons. Just under £40k total, i.e. equivalent of two vintage prints by Stieglitz at that time.'

26 S. Walker, *Helen Chadwick: Constructing Identities Between Art and Architecture*, *op. cit.*, passim.

27 Marina Warner, 'In the Garden of Delights: Helen Chadwick's "Of Mutability"', in *Of Mutability, Helen Chadwick* (exh. catalogue), London: ICA, 1986, unpaginated. Reprinted in Helen Chadwick, *Enfleshings*, London: Secker & Warburg, 1989, pp.39-64.

28 Page of notes, with quotes from Chadwick on *The Oval Court*. Box 24, HMI.

29 H. Chadwick, Notebook 19/E/7, HMI.

30 Declan McGonagle was the director of the ICA; the curators who commissioned the work and supported Chadwick's ambitious vision were James Lingwood and Iwona Blazwick.

31 H. Chadwick, Notebook 19.7, HMI.

32 H. Chadwick, cuttings on 'Extispicy'. Box 1 (b), HMI.

33 H. Chadwick, Notebook 19/E/7, HMI.

34 Jennifer Milam, 'Rococo Representations of Interspecies Sensuality and the Pursuit of *Volupté*', *The Art Bulletin*, vol.97, no.2, June 2015, pp.192-209.

35 H. Chadwick and Judith Collins, 'An Opera for Milly Mudd: Artist Helen Chadwick in Conversation with Judith Collins', *From Marble to Chocolate: The Conservation of Modern Sculpture*: Tate Gallery Conference, 18-20 September 1995 (ed. Jackie Heuman), London: Archetype Publications, 1995, p.154.

36 S. Walker, 'The Grotto and Architectural conceit', *op. cit.*, p.113.

37 H. Chadwick, Notebook 19.E/7, HMI; Chris Blackford, 'The Burden of Physicality: Interview with Helen Chadwick', recorded at Birmingham Museum and Art Gallery, 1986, published in *Rubberneck*. Available at http://www.users.globalnet. co.uk/~rneckmag/chadwick.html (last accessed 12 January 2022). See Box 3, HMI.

38 *Rococo: Art and Design in Hogarth's England* (exh. catalogue), Victoria and Albert Museum, London: Trefoil Books, V&A, 1984. On the question of style, see especially Michael Snodin, 'English Rococo and its Continental Origins', *op. cit.*, pp.227-33.

39 See Anna Maria Garthwaite, *Pattern Books*, VAM T.391-1971 and Nathalie Rothstein, 'Silk Design', in *Rococo Art and Design in Hogarth's England*, *op. cit.*, pp.214-222 and pp.223-234 for many examples.

40 Remembered by Alison Turnbull, private communication with the author, 8 October 2021.

41 H. Chadwick and J. Collins, 'An Opera for Milly Mudd', *op. cit.*, p.160.

42 H. Chadwick, Notebook 19/E/7.61, HMI; quoted in S. Walker, 'The Grotto and Architectural Conceit', *op. cit.*, p.116.

43 Italo Calvino, *Six Memos for the Next Millennium* (trans. Geoffrey Brock), London: Penguin Books, 2016, pp.3-29.

44 The OED cites a translation of Winckelmann by the artist Henry Fuseli in 1765; 'barocco' was in usage in Europe long before this date.

45 Postcard dated Good Friday, 1984, in the Helen Chadwick papers at the V&A Collections. As the artist Chris Bucklow, Titterington made two of his pinprick light portraits of Chadwick in silhouette, titled *Guest* (1993) and *Sleeping Guest* (1996).

46 Reproduced in *De Light* with essays by Thomas McEvilley, Richard Howard, and Melissa E. Feldman (exh. catalogue), Philadelphia: Institute of Contemporary Art, University of Pennsylvania, 1991.

47 'Le cabinet des beaux-arts, ou Recueil d'estampes gravées d'après les tableaux d'un plafond où les beaux-arts sont représentés', *Gallica*, available at https://gallica.bnf.fr/ ark:/12148/btv1b86262227/f81.item (last accessed 12 October 2021).

48 H. Chadwick in I. Gale, 'Helen Chadwick talking to Iain Gale', *op. cit.*, pp.106-107.

49 'There is a dark northern strain in Chadwick's imagination which runs counter to all the rococo effervescence. The encounter between them could have produced a jarring disloca- tion, but she manages to fuse sensuality and transience in a work which yields remarkable richness.' Richard Cork, 'Attitudes of Bliss', *The Listener*, 12 June 1986. Box 3, HMI.

50 William Feaver, *The Observer* (undated clipping). Box 3, HMI.

51 Mary Kelly quoted in Marjorie Allthorpe-Guyton, 'Helen Chadwick', *Art Monthly*, no.100, October 1986, p.18. Box 3, HMI.

52 M. Allthorpe-Guyton, 'Helen Chadwick', *ibid.*

53 *Ibid.*

54 Michael Newman, 'The Body as Emblem', *Artscribe International*, no.60, November/December 1986, p.61.

55 For Rococo, see *Rococo: The Continuing Curve, 1730-2008* (museum cat.), New York: Smithsonian Institution, 2008; see especially Gail S. Davidson, 'Ornament of Bizarre Imagination', pp.40-71, Sarah D. Coffin, 'Radiating Rococo', pp.104-135, and Ulrich Leben, 'German Rococo', pp.136-41.

56 H. Chadwick interview with Emma Cocker, 'Indifference in Difference', 2 December 1995 (draft). Box 135, HMI; published in *MAKE*, Women's Art Magazine, London, no.71, August 1996, p.22.

57 H. Chadwick and J. Collins, 'An Opera for Milly Mudd', *op. cit.*

58 See Joan DeJean's fascinating history, *The Queen's Embroiderer: A True Story of Paris, Lovers, Swindlers, and the first Stock Market Crisis*, London: Bloomsbury, 2018.

59 Ellen Willis, 'Lust Horizons: Is the Women's Movement Pro-Sex?', *No More Nice Girls: Countercultural Essays*, Minneapolis: University of Minnesota Press, 2012, quoted in Alexandra Schwartz, 'Tell Me What You Want: Review of Amia Srinivasan, *The Right to Sex*', *The New Yorker*, 4 October 2021, available at https://www.newyorker.com/maga-zine/2021/10/04/were-shaped-by-our-sexual-desires-can-we-shape-them (last accessed 12 October 2021).

60 H. Chadwick, Notes, in the Helen Chadwick papers at the V&A Collections.

61 I remember she was a controversial figure, especially among feminists of the time, as to some extent I was too - so I was aware of these conflicts.

62 Laura Cottingham, and Cherry Smith, *Bad Girls* (exh. cat.), University of Michigan, 1993, London: ICA, 1994, p.55; quoted in Niclas Östlind, 'Notes on the Art of Helen Chadwick, especially the early works', *Helen Chadwick*, Stockholm: Liljevachs Konsthall, 2005, p.34.

63 The show was reconstructed in *My Personal Museum: Ego Geometria Sum from the Helen Chadwick Archive* (exh. leaflet), Henry Moore Institute, Leeds, 6 March-5 June 2004, with contributions to the leaflet from Stephen Feeke and Eva Martischnig and some very rich personal material from the Archive. Box 18, HMI.

64 Andy Beckett, 'What a Swell Party It Was', *The Independent*, 1 June 1996.

65 Gray Watson, 'Notes to accompany *Life Sighs in Sleep*', photocopy. Box 1(b), HMI.

66 H. Chadwick, Tape 2/8, 12'45, BL.

67 H. Chadwick, *Artists' Journeys: Helen Chadwick on Frida Kahlo*, London: BBC 2, 1992.

68 Jo Spence, *Putting Myself in the Picture: A Political, Personal, and Photographic Autobiography*, London: Camden Press, 1986.

69 *Cinderella* was directed by Melissa Llewellyn-Davies and presented by myself. *Arena*, BBC Two, 21 January 1986; J. Spence, *Fairy Tales and Photography, or, another look at Cinderella*, intro. by M. Warner, London: James Hyman Collection, 2020 (including her MA thesis *Class Slippers*).

70 H. Chadwick, Tape 2/8, 7'56, BL; *Studio Girls* (*Domestic Sanitation*, *The Last Glamour Rodeo* and *Bargain Basement Bed Bonanza*) were performed in Brighton in 1976; a half hour Super 8 film exists of the performance, and is available from the LUX collection at https://lux.org.uk/work/domestic-sanitation (last accessed 12 January 2022); see also N. Östlind, 'Notes on the Art of Helen Chadwick', *op. cit.*, pp.1-13.

71 *Ibid.*, pp.16-19.

72 H. Chadwick, Notes, in the Helen Chadwick papers at the V&A Collections.

73 Filofax notes, quoted in S. Walker, 'The Grotto and Architectural Conceit', *op. cit.*, p.99.

74 Pete Smith remembers, 'Apart from Genesis, who I think started out a squatter … we were licensees via ACME and we paid rent and rates. Licensee was a strange category to be in, one up from squatters in that you were legal and had permission to occupy the short-life houses but without tenants' rights. We signed a contract agreeing to leave without fuss with 2 weeks notice as and when required to. It may have been 3 weeks, don't remember clearly but something like that. So a bit precarious.' Personal communication with the author, 11 January 2022.

75 *Art History: Artists Look at Contemporary Britain* (exh. cat.), curated by Catherine Lampert, Hayward Touring Exhibitions, London: South Bank Centre, 1988.

76 Paula Brooking, also known as Paula P-Orridge, is an English musician, writer and entrepreneur, now using the name Alaura O'Dell. She was married to the English musician Genesis P-Orridge, and had two daughters with P-Orridge, Caresse and Genesse. She was member of P-Orridge's band Psychic TV.

77 Chadwick, Tape 1/8, 30', BL. Her parents had separated when she was 'around thirteen' and she told Haworth-Booth that, after she had been accepted at Exeter University to study archaeology and anthropology, she switched 'at the eleventh hour' to Croydon School of Art because she wanted to remain near her mother at that time.

78 Alberto Veca, *Vanitas: il simbolismo del tempo* (exh. cat.), Galleria Lorenzelli, Bergamo: La Galleria, 1981.

79 Angela Carter, 'Brooksie and Faust: Review of Louise Brooks by Barry Paris', *London Review of Books*, vol.12, no.5, 8 March 1990.

80 M. Haworth-Booth, *Wild Track: poems with pictures by friends*, Weymouth: Trace Editions, 2005, p.39.

81 Cathy Watkins, 'Naym No Body Images of a Voice', exh. leaflet for an exhibition of Hermione Wilshire, Richard Wentworth, at Riverside Studios, London, 1991. Box 1, HMI.

82 Thomas J. Lax, 'Interview with Carolee Schneemann, about the performance of *Meat*

Joy at Judson Dance Theater', available at https://www.moma.org/audio/playlist/53/783 (last accessed 12 October 2021).

83 Letter from a fan, Box 100, HMI.

84 H. Chadwick, Notebook, 19/E/7/69, HMI, quoted in S. Walker, 'The Grotto and Architectural Conceit', *op. cit.*, p.109.

85 Julia Kristeva, 'Histoires d'amour', in Lisa Appignanesi (ed.), *ICA Documents 1: Desire*, London: ICA, 1984, unpaginated.

86 H. Chadwick, Notebook 19.7., HMI, quoted in M. Warner, 'In the Garden of Delights', *Of Mutability*, *op. cit.*, unpaginated.

87 H. Chadwick, Notes, in the Helen Chadwick papers at the V&A Collections.

88 See M. Warner, 'Hans Baldung Grien: A Fatal Bite', in *Forms of Enchantment: Writings on Art & Artists*, London: Thames & Hudson, 2018, pp.79-94.

89 H. Chadwick, Tape 6/8, 1'5, BL.

90 From a photocopied page. Box 24, HMI.

91 Mary Horlock, 'Between a Rock and a Soft Place', in Mark Sladen (ed.), *Helen Chadwick* (exh. cat.), London: Barbican Art Gallery, Hatje Cantz Publishers, Ostfildern-Ruit, 2004, p.43.

92 H. Chadwick and J. Collins, 'An Opera for Milly Mudd', *op. cit.*, p.160.

93 H. Chadwick quoted in M. Warner, *Of Mutability*, *op. cit.*, unpaginated.

94 Aristotle, *De Anima* II.8. 420b6, 30-5, *On the Soul* (trans. W. S. Hett), Loeb Classical Library, Cambridge, MA and London: Harvard University Press, [1936] 1995, pp.119-121.

95 H. Chadwick, *Enfleshings I* (1989), quoted in *De Light*, *op. cit.*, and in M. Warner, 'Helen: A Eulogy', in *Wreaths to Pleasure* (exh. cat.), London: Richard Saltoun/ Ridinghouse, 2014, p.54.

96 Boris Vian, 'L'amour est aveugle', in Noel Arnaud (ed.), *Le Loup-garou: Suivi de douze autres nouvelles*, Paris: Christian Bourgois, 1970, pp.89-90.

97 I drafted the plans with Lisa Appignanesi as producer in 1992, I think, for Channel Four. Other writers were to be involved. I was reminded of this project during the pandemic when we were allowed to see one another but forbidden to meet – and to touch. I was able to explore the theme in a dance piece, choreographed by Kim Brandstrup, which closed a concert of pieces inspired by myths; the programme was devised by the violinist Sara Trickey under the overall title, *Dancing with Apollo*, July 2021, Kings Place London. See review by Tim Ashley, *Guardian*, 12 July 2021, available at https://www.theguardian.com/music/2021/jul/12/dancing-with-apollo-review-kings-place-london-spitalfields-music-festival (last accessed 12 January 2022).

98 The artist attended to every detail in two major publications: *Enfleshings*, *op. cit.*, and *Effluvia*, ed. Andrea Schlieker, London: Serpentine Galleries, 1994.

99 H. Chadwick, Tape 1/8, 26', BL.

100 H. Chadwick and J. Collins, 'An Opera for Milly Mudd', *op. cit.*, p.160.

101 Adam Farah (b. 1991) recently showed a tribute to Cacao in his show, *What I've learned from you and myself (Peak Momentations/Inside My Velvet Rope Mix)*. A circular fountain called *TIME (The Endz Portorbital Alchemical Mix)*, 2021, spouted K.A. Sparkling Black Grape Drink. He is one of many younger artists who are indebted to Chadwick.

102 H. Chadwick and J. Collins, 'An Opera for Milly Mudd', *op. cit.*, p.160.

103 Charles Baudelaire, 'Fusées' (Squibs), in *Intimate Journals* (trans. Christopher Isherwood), London: Methuen, 1949, p.15; quoted in Christopher Turner, *The Disgusting: The Unrepresentable from Kant to Kristeva*. PhD Thesis (London Consortium, 2000). I am grateful to the author for letting me read a part of his work entitled 'Excremental Visions: Disgust and the Avant-Garde.'

104 Chadwick's copy of *The Foul and the Fragrant* by Alain Corbin (1982) is heavily marked up.

105 J. Kristeva, *Strangers to Ourselves* (trans. Leon S. Roudiez), New York: Columbia University Press, 1991.

106 See L. Buck, 'Unnatural Selection', and M. Warner 'In Extremis: Helen Chadwick & the Wound of Difference', in *Stilled Lives*, *op. cit.*, unpaginated.

107 David Alan Mellor, 'The Cameos', in *Stilled Lives*, *op. cit.*, unpaginated.

108 H. Chadwick, Tape 5/8, 28'44, BL.

109 S. Walker, 'The Grotto and Architectural Conceit', *op. cit.*, p.100.

110 *Ibid.*, p.119.

111 While making *Lofos Nymphon*, she wrote: 'Facing open rupture, the wound of difference, what a solace it would be to construct a haven for the disembodied memories of pleasure at the mother's breast ...a chamber where... I might resurrect the lost archaic contact safely...' *Lofos Nymphon* (exh. cat.), Sheffield, 1987; quoted in M. Warner, 'Helen Chadwick: The Wound of Difference', in *Forms of Enchantment*, *op. cit.*, p.121.

112 Ted Hughes, 'Salmacis and Hermaphroditus', in Michael Hofmann and James Lasdun (ed.), *After Ovid: New Metamorphoses*, London: Faber & Faber, 1994, p.116.

113 H. Chadwick, 'Objects, Signs, Commodities', *Camera Austria International*, no.37, Summer 1991, p.10; quoted in M. Horlock, 'Between a Rock and a Soft Place', *op. cit.*, p.41.

114 Butler then poses two questions, both central to Chadwick's vision: first, does the state of 'undifferentiation suggest the possibility of a collapse of gender into a bisexual or androgynous model?' And, secondly, 'Can the body be represented as an ontologically transparent layer through which art and science are mutually visible?' Jack Butler, 'Before Sexual Difference: The Art and Science of Genital Embryogenesis', *Leonardo*, vol.26, no.3, 1993, p.193.

115 Thomas Laqueur, *Making Sex: Body and Gender from the Greeks to Freud*, Cambridge, MA: Harvard University Press, 1992.

116 Michael Neve, 'Animal Crackers', *London Review of Books*, vol.8, no.9, 22 May

1986; Chadwick also kept a cutting of another review of the same book, *Times Literary Supplement*, 4 April 1986. Box 38, HMI.

117 H. Chadwick, Tape 1/8, 25'50, BL.

118 H. Chadwick interview with Emma Cocker, 'Indifference in Difference', *op. cit.*

119 H. Chadwick, Tape 6/8, 27'25, BL.

120 H. Chadwick, 'Piss Posy', *op. cit.*, p.3.

121 Andy Beckett claims he was the only journalist to attend the inquest, which appears to have been inconclusive: her heart attack was ascribed - possibly - to myocarditis. See A. Beckett, 'What A Swell Party It Was', *op. cit.*

122 I recast the obituary I wrote (*Guardian*, 18 March 1996) for the Memorial address. It was reprinted, slightly revised, as 'Helen: A Eulogy', *op. cit.*, pp.52-57.

123 Kathleen Jamie, 'The Oval Court', in *Writers on Chadwick: Poems Inspired by the Work of Helen Chadwick*, London: Barbican Education, 2004, unpaginated. The other poems were by Jackie Kay, Jo Shapcott (two), Lavinia Greenlaw, and Gwyneth Lewis.

Notes